A Cavalier History of Surrealism

A Cavalier History of Surrealism

by Jules-François Dupuis
(Raoul Vaneigem)

Translated by Donald Nicholson-Smith

Edinburgh • London • San Francisco

First published as *Histoire désinvolte du surréalisme* by Paul Vermont, Nonville, France, 1977.

English translation copyright © 1999 by Donald Nicholson-Smith.

ISBN 1-873176-94-5

Library of Congress Cataloging in Publication Data: A catalog record for this title is available from the Library of Congress.

British Library Cataloguing-in-Publication Data: A catalogue record for this title is available from the British Library.

AK Press
PO Box 12766
Edinburgh
Scotland EH8 9YE

AK Press
PO Box 40682
San Francisco, CA 94140-0682
USA

Author's Note

Commissioned in 1970 by a French publisher who planned to issue it in a series intended for high-school pupils, this *Histoire désinvolte du surréalisme* was written in a couple of weeks under the pressure of a contractual deadline. The fact that the original bearer of the name chosen as a pseudonym, "Jules-François Dupuis", was the janitor of the building where Lautréamont died, and a witness to his death certificate, should be a clear enough sign that this book is not one of those that are particularly dear to my heart; it was merely a diversion.

When the original publisher's projected series was abandoned, the manuscript was returned to me. It then languished for some years at the house of a friend, who in 1976 showed it to a young publisher of her acquaintance. As a result it was published a year later (Nonville: Paul Vermont). It was reprinted in 1988 (Paris: L'Instant). Perhaps it is fair to say that, despite its polemical character and peremptory tone, it remains a useful "schoolbook"—and one which may steer those just discovering Surrealism away from a certain number of received ideas.

R.V.

TABLE OF CONTENTS

CHAPTER 1

HISTORY AND SURREALISM

THE CRISIS OF CULTURE

Surrealism belongs to one of the terminal phases in the crisis of culture. In unitary régimes, of which monarchy based on divine right is the best known example, the integrative power of myth concealed the separation between culture and social life. Artists, writers, scholars and philosophers, just like the peasants, the bourgeois, the wielders of power, and even the King himself, had to live out their contradictions within a hierarchical structure which was from top to bottom the work of a God, and unchangeable in its very essence.

The growth of the bourgeois class of merchants and manufacturers meant the moulding of human relationships to the rationality of exchange, the imposition of the quantifiable power of money with mechanistic certainty as to its concrete truth. This development was accompanied by an accelerating tendency toward secularization which destroyed the formerly idyllic relationship between masters and slaves. The reality of class struggle broke upon history with the same brutality as the reign of economics, which had suddenly emerged as the focus of all preoccupations.

Once the divine State, whose form constituted an obstacle to the development of capitalism, had been done away with, the exploitation of the proletariat, the forward march of capital, and the laws of the commodity, by everywhere bending beings and things to their will, became cumbersome realities susceptible neither to the authority of a divine providence nor to incorporation into the myth of a transcendent order: realities which the ruling class, if it was not to be borne away by the next revolutionary wave—already incontestably foreshadowed by the Enragés and Babouvists—was now obliged at all costs to conceal from the consciousness of the proletariat.

Out of the relics of myth, which were also the relics of God, the bourgeoisie sought to construct a new transcendent unity capable of using the force of illusion to dissolve the separations and contradictions that individuals deprived of religion (in the etymological sense of a collective bond with God) experienced within themselves and

3

between each other. In the wake of the abortive cults of the Supreme Being and the Goddess of Reason, nationalism in its multifarious guises—from Bonaparte's Caesarism to the gamut of national socialisms—came to the fore as the necessary but increasingly inadequate ideology of the State (whether the State of private and monopolistic capitalism or the State of capitalism in its socialized form).

Indeed, the fall of Napoleon marked the end of any prospect of reinstituting a unitary myth founded on empire, on the prestige of arms or on the mystique of territorial power. All the same, there is one trait common to all the ideologies that evolved either from the memory of the divine myth, or out of the contradictions of the bourgeoisie (liberalism), or by way of the deformation of revolutionary theories (that is, theories thrown up by real struggles which feed back into those struggles and hasten the advent of a classless society by remaining necessarily opposed to all ideology). That common trait is the same dissimulation or distortion, the same deprecation or misapprehension, of the real movement that arises from human praxis.

The radical consciousness cannot be reconciled with ideology, whose only function is to mystify. What the acutest eighteenth-century consciousness perceived for the most part, in the void left behind by the ebb tide of divine consciousness, was the suffering of separation, isolation and alienation. Disenchantment (in the literal sense of the end of the spell cast by a unifying God) thus went hand in hand with an awareness of contradictions that had no chance of being resolved or transcended.

As all sectors of human activity proceeded to break apart from one another, culture, just as much as the economic, social or political spheres, became a separate realm, an autonomous entity. And as the masters of the economy gradually built up their hegemony over society as a whole, artists, writers and thinkers were left in possession of the consciousness of an independent cultural domain which the imperialism of the economy would be very slow to colonize. They turned this domain into a citadel of the gratuitous, but they

acted as mercenaries of dominant ideas as often as they raised the flag of rebellion or revolution.

Victims of the unhappy consciousness, despised by those concerned with finance, trade and industry, these creators tended in the main to turn culture into a replacement for myth, into a new totality, a reconsecrated space starkly opposed to the material spheres of commercial transaction and production. Naturally, since the area they governed was no more than a fragment, irreducible to economic terms and cut off from the social and the political, they could not aspire to any genuine resuscitation of the unitary myth: all they could do was *represent* it—and in this respect indeed they were no different from the more astute minds of the bourgeoisie, seeking to build a new myth by resacralizing all those zones where the economy did not intervene directly (no attempt would be made to consecrate the Stock Exchange, for instance, but the cult of work was an attempt to sanctify the factory).

The "spectacle" is all that remains of the myth that perished along with unitary society: an ideological organization whereby the actions of history upon individuals themselves seeking, whether in their own name or collectively, to act upon history, are reflected, corrupted and transformed into their opposite—into an autonomous life of the non-lived.

We shall understand nothing of Romanticism, nor of Surrealism, if we lose sight of culture's entanglement with the organization of the spectacle. To begin with, everything new thrown up by these movements bore the stamp of a rejection of the bourgeoisie, a refusal of everything utilitarian or functional. There is no artist of the first half of the nineteenth century whose work was not grounded in contempt for bourgeois and commercial values (which of course in no way prevented artists from behaving exactly like bourgeois and taking money wherever they could get it—Flaubert is a case in point). Aestheticism acquired ideological force as the contrary of commercial value, as the thing which could make the world worth living in, and which thus held the key to a particular style of life, a particular

way of investing being with value that was diametrically opposed to the capitalist's reduction of being to having. Within the spectacle, it was culture's task to supply validating role models along these lines. Gradually, as economic rationality created a cultural market, transforming books, pictures or sculpture into commodities, the dominant forms of culture became ever more abstract, eventually calling forth anti-cultural reactions. At the same time, the greater the sway of the economy, and the more widely it imposed its commodity system, the greater was the bourgeoisie's need to update its spectacular ideological free market as a way of masking an exploitation that was ever more brutal—and ever more brutally contested by the proletariat. After the Second World War, the collapse of the great ideologies and the expanding consumer market, with its books, records and culturalized gadgets, brought culture to centre stage. The poverty of the mere survival imposed on people accentuated this development by encouraging them to live abstractly, in accordance with models whose universal fictions, dominated by stereotypes and images, were continually in need of renewal. Surrealism would pay the price here, in the coin of a co-optation which its heart, if not its intellect, had always refused.

Culture, however, was not a monolith. As a separate sphere of knowledge, it inevitably attested to the splits that had been brought about; it remained the locus of partial forms of knowledge that claimed to be absolute in the name of the old myth, which, though irremediably lost, was forever being sought after. The consciousness of creators underwent a corresponding evolution, as culture established a parallel market of its own (around 1850?), so giving rise to 'units' of prestige which in the spectacular system replaced profit, or refined it, and in any event interacted with it.

Creators who failed to burst the bubble in which they were usually content to generate endless reflections of themselves risked becoming mere producers of cultural commodities or functionaries of the ideological-aesthetic spectacle. The man of refusal, so defined by the scorn poured upon him by the world of commerce, could very

6

easily be transformed into a bearer of false consciousness. When reproached by the businessman for not having his feet on the ground, the artist tended to appeal to the life of the mind. Surrealism bore the traces of this absurd antagonism between mercantile "materialism" on the one hand and Mind (whether in its reactionary or its revolutionary form) on the other.

All the same, the more lucid or sensitive creators succeeded in identifying their own condition more or less clearly with that of the proletariat. The result was a tendency that might be called "radical aesthetics"—exemplified by Nerval, Stendhal, Baudelaire, Keats, Byron, Novalis, Büchner, Forneret, Blake, etc.—for which the quest for a new unity was expressed through the symbolic destruction of the old world, the provocative espousal of the gratuitous, and the rejection of commercial logic and the immediate concrete dimension which that logic controlled and defined as the only reality. Hegel would come to represent the historical consciousness of this attitude.

Another tendency, extending "radical aesthetics" into a "radical ethics", arose from an awareness of the separatedness of culture, from the consciousness of thinkers and artists, hitherto alienated in the pure impotence of the mind, who now developed creativity as a mode of authentic existence welded to the critique of the commodity system and of the survival imposed universally by that system. Marx and Fourier were this tendency's main voices.

Lastly, there was a third current which, without grounding itself as firmly in history as Marx or Fourier, made its basic principle the abolition of culture as a separate sphere through the realization of art and philosophy in everyday life. This tradition runs from Meslier to de Sade, and thence, via Petrus Borel, Hölderlin, Charles Lassailly, Ernest Coeurderoy, Joseph Déjacque and Lautréamont, to Ravachol and Jules Bonnot. It is in fact less a tradition than a somewhat serendipitous tracery of theories and practices constituting a kind of ideal map of radical refusal. Though thrown up by history, and reinserting itself into history, often in violent fashion, this was a heritage with no clear consciousness of its power over that history, no effective knowledge of its

actual potential. In the years between 1915 and 1925, however, as history took its revenge upon all its ideological travesties, these isolated voices were revealed as eminently harmonious, called forth as they all were by the pressure for human emancipation.

Dada embodied both the consciousness of the crumbling of ideology and the will to destroy ideology in the name of authentic life. But Dada in its nihilism sought to constitute an absolute—and hence purely abstract—break. Not only did it fail to ground itself in the historical conditions by which it had itself been produced, but, by deconsecrating culture, by mocking its claims to be an independent sphere, by playing games with its fragments, it effectively cut itself off from a tradition forged by creators who in fact shared Dada's goal, the *destruction* of art and philosophy, but who pursued this goal with the intention of *reinventing and realizing* art and philosophy—once they had been liquidated as ideological forms, as components of culture—in everyone's actual life.

After Dada's failure, Surrealism for its part renewed ties with the older tradition. It did so, however, just as though Dada had never existed, just as though Dada's dynamiting of culture had never occurred. It prolonged the yearning for transcendence, as nurtured from de Sade to Jarry, without ever realizing that the transcendence in question had now become possible. It curated and popularized the great human aspirations without ever discovering that the prerequisites for their fulfilment were already present. In so doing, Surrealism ended up reinvigorating the spectacle, whose function was to conceal from the last class in history, the proletariat, bearer of total freedom, the history that was yet to be made. To Surrealism's credit, assuredly, is the creation of a school-for-all which, if it did not make revolution, at least popularized revolutionary thinkers. The Surrealists were the first to make it impossible, in France, to conflate Marx and Bolshevism, the first to use Lautréamont as gunpowder, the first to plant the black flag of de Sade in the heart of Christian humanism. These are legitimate claims to glory: to this extent, at any rate, Surrealism's failure was an honourable one.

DADA AND CULTURE IN QUESTION

Dada was born at a turning-point in the history of industrial societies. By reducing human beings to citizens who kill and are killed in the name of a State that oppresses them, the model ideologies of imperialism and nationalism served to underline the gulf that separated real, universal man from the spectacular image of a humanity perceived as an abstraction; the two were irreparably opposed, for example, from the standpoint of France, or from the standpoint of Germany. Yet at the very moment when spectacular organization reached what to minds enamoured of true freedom appeared to be its most Ubuesque representational form, that organization was successfully attracting and enlisting almost all the intellectuals and artists to be found in the realm of culture. This tendency arose, moreover, in tandem with the move of the proletariat's official leadership into the militarist camp.

Dada denounced the mystificatory power of culture *in its entirety* as early as 1915-1918. On the other hand, once Dada had proved itself incapable of realizing art and philosophy (a project which a successful Spartacist revolution would no doubt have made easier), Surrealism was content merely to condemn the spinelessness of the intelligentsia, to point the finger at the chauvinist idiocy of anyone, from Maurice Barrès to Xavier Montehus, who was an intellectual and proud of it.

As culture and its partisans were busily demonstrating how actively they supported the organization of the spectacle and the mystification of social reality, Surrealism ignored the negativity embodied in Dada; being nevertheless hard put to it to institute any positive project, it succeeded only in setting in motion the old ideological mechanism whereby today's partial revolt is turned into tomorrow's official culture. The eventual co-optation of late Dadaism, the transformation of its radicalism into ideological form, would have to await the advent of Pop Art. In the matter of co-optation, Surrealism, its protestations to the contrary notwithstanding, was quite sufficient unto itself.

9

The ignorance that Surrealism fostered with respect to the *disso-lution* of art and philosophy is every bit as appalling as the ignorance Dada fostered with respect to the opposite aspect of the same tendency, namely the *transcendence* of art and philosophy.

The things that Dada unified so vigorously included Lautréamont's dismantling of poetic language, the condemnation of philosophy in opposing yet identical ways by Hegel and Marx, the bringing of painting to its melting point by Impressionism, or theatre embracing its own parodic self-destruction in *Ubu*. What plainer illustrations could there be here than Malevich with his white square on a white ground, or the urinal, entitled *Fountain*, which Marcel Duchamp sent to the New York Independents Exhibition in 1917, or the first Dadaist collage-poems made from words clipped from newspapers and then randomly assembled? Arthur Cravan conflated artistic activity and shitting. Even Valéry grasped what Joyce was demonstrating with *Finnegans Wake*: the fact that novels could no longer exist. Erik Satie supplied the final ironic coda to the joke that was music. Yet even as Dada was denouncing cultural pollution and spectacular rot on every side, Surrealism was already on the scene with its big plans for clean-up and regeneration.

When artistic production resumed, it did so against and without Dada, but against and *with* Surrealism. Surrealist reformism would deviate from reformism's well-trodden paths and follow its own new roads: Bolshevism, Trotskyism, Guevarism, anarchism. Just as the economy in crisis, which did not disappear but was instead transformed into a crisis economy, so likewise the crisis of culture outlived itself in the shape of a culture of crisis. Hence Surrealism became the spectacularization of everything in the cultural past that refused separations, sought transcendence, or struggled against ideologies and the organization of the spectacle.

THE BREAK FROM DADA

When exactly did Surrealism emancipate itself from Dada? The question is badly framed, because it suggests that the Surrealists were reconstructed Dadaists, which is far from certain. Indeed, if we look closely at the beginnings of the earliest proponents of Surrealism, we find that their works are of a personal kind, hostile, certainly, to the dominant tradition, but bearing scant trace of Dada's corrosive spirit.

The good relations maintained by the early Surrealists with Pierre Reverdy, editor of the literary review *Nord-Sud*, or the poems of Breton, Benjamin Péret, Paul Éluard or Philippe Soupault, are quite adequate testimony to the adherence of these new voices to a certain conception of *literature*. What the first Surrealists knew of Dada was above all its edulcorated Parisian version, the antics of Tzara, and a few clashes between individuals. With Grosz, Huelsenbeck, Schwitters, Haussmann, Jung or even Picabia they were still largely unacquainted.

In 1917 the word "surrealist" appeared in the subtitle to Apollinaire's play *Les Mamelles de Tirésias* [The Teats of Tiresias]. In 1920 Paul Dermée used the term in the review *L'Esprit Nouveau*, and in 1924 Yvan Goll chose it as the title of a periodical that lasted for only one issue.

As early as 1919, however, the concept had acquired less vague connotations. In that year Aragon produced his first automatic texts. In "Entrée des médiums" [Enter the Mediums], Breton sought to circumscribe the notion—a task that he would pursue further in the first *Manifesto of Surrealism* (1924). From the outset "surrealism" signified a new quest; the word immediately became the label of a new cultural product, clearly reflecting the will to distinguish that product unequivocally from all others. The contradiction between a voluntaristic rigour and the inclination to compromise that was objectively encouraged by Surrealism's fresh embrace of culture created a permanent point of stress and led to endless splits in the movement.

The review *Littérature*, founded in 1919, was so named by antiphrasis, but from the beginning it retained not a few genuinely literary aspects; even in appearance it resembled a traditional literary magazine in many respects. This was the starting point for the Surrealist project of founding a new way of thinking, feeling and living, of creating a new world; and here lay the seeds of the particular way in which this project would be worked out, as of the particular way in which it would fail. In the regressive conjuncture which followed the triple defeat of Spartacus, of Dada and of the revolution of the Soviets in Russia (co-opted by the Bolsheviks), the Surrealists made a promise which they kept: to be the capricious consciousness of a time without consciousness, a will-o'the-wisp in the night of National Socialism and National Bolshevism.

The first few issues of *Littérature* included contributions from Valéry, Gide, Léon-Paul Fargue, Blaise Cendrars, Jules Romains, Max Jacob, Georges Auric and Darius Milhaud. The young Breton admired Valéry, Pierre Reverdy and Saint-Pol-Roux, and to the last of these he remained loyal his whole life long; yet he also had a fascination for Arthur Cravan and Jacques Vaché, prime exemplars of Dada nihilism authentically lived out. In a sense Breton's work and even Surrealism itself were the product of these two divergent orientations.

The implications of this double allegiance are clear from Breton's remarks in the *Second Manifesto of Surrealism* (1930):

> In spite of the various efforts peculiar to each of those who used to claim kinship with Surrealism, or who still do, one must ultimately admit that, more than anything else, Surrealism attempted to provoke, from the intellectual and moral point of view, *a crisis of consciousness* of the most general and serious kind, and that the extent to which this was or was not accomplished alone can determine its historical success or failure.

The restriction here to "the intellectual and moral point of view" clearly indicates an attachment to culture as an independent sphere, while "a crisis of consciousness of the most general and seri-

ous kind" evokes what Surrealism would inherit, albeit superficially, of the Dada spirit.

In fact Dada precipitated the purging of *Littérature*: it was under Dada's influence that quarrels between *littérateurs* metamorphosed into a general hostility towards the *homme de lettres* per se—that animosity towards a Max Jacob, an André Gide or a Jean Cocteau came to be justified in terms of contempt for writing as a trade or craft.

In 1920 *Littérature's* thirteenth issue opened the doors wider than ever before to the Dadaist influence, publishing twenty-three of the movement's manifestoes. Simultaneously, however, the break between André Breton and Tristan Tzara was in the making.

Breton's intelligence and discretion undoubtedly endowed Surrealism with a good part of its genius. For Dada, unfortunately, just the opposite occurred: already sorely lacking for revolutionary theorists, it lost much of its rich potential when it came under the thumb of Tzara, the poverty of whose ideas and the banality of whose imagination were only rivalled by his lust for recognition, for celebrity.

Tzara possessed nothing of the critical sense and clear-minded combativeness needed to incite artists to despair of art, grasp hold of everyday life and transform themselves into the subject of a collective work of revolution. And the said artists, indecisive and at bottom more susceptible to the temptation of an artistic career than they cared to acknowledge, quickly discovered that repeating the familiar japes of Dada's anti-art "show", with Tzara as choreographer and star, offered a convenient way of surreptitiously resuming cultural activity without formally renouncing the Dadaist contempt for art: they merely had to pretend to believe that that contempt applied solely to the dominant forms of literature, thought or art. In a sense, Surrealism itself resided in these shortcomings of Dada.

Littérature's survey based on the question "Why do you write?" was not so radical as one might justifiably have supposed at first glance. True, it clearly exposed the general vulgarity of intent and lack of imagination of the makers of novels, the asininity of versifiers and academic thinkers, yet at the same time it laid the groundwork

for the "discovery" of profounder justifications for a new art of writing, feeling, or painting and authorized a new form of expression with claims to being authentic and total.

Such a form of expression already existed experimentally. As Breton recalls in *Entretiens* [Conversations (1952)], "In 1919, I began paying attention to those more or less complete sentences which, when one was entirely alone, as sleep came on, would become perceptible to the mind without it being possible to find any pre-existing reason for them."

The practical results appeared in a joint work by Breton and Soupault, *The Magnetic Fields* (1920), supposedly written under the direct dictates of the unconscious. The book foreshadowed the later experimental "sleeping" by means of which Robert Desnos, Benjamin Péret and René Crevel sought to express themselves without any mediation by the conscious mind.

By the time Breton took over as editor of a new series of *Littérature* in March 1922, and evenhandedly rejected both Dadaism and the literary brigade (Gide, Valéry and Co.), he already had a clear agenda, in the form of a *positive* project.

The coming break with Dada was hastened in 1921 by a public event organized by Aragon and Breton: the "indictment and trial of Maurice Barrès". Barrès was a literary anarchist of the "cult of the Ego" variety who sang the praises of nationalism in dulcet tones. He was, in short, the perfect symbol of a fin-de-siècle intelligentsia that now practised the poetry of the bugle-call, thus by their negative example justifying the proponents of a culture free of "intellectual bloodstains".

The trial was held on 13 May. The accused was represented by a carnival manikin; Breton presided, Georges Ribemont-Dessaignes took the role of public prosecutor, and Soupault and Aragon, who had every a priori reason to like Barrès, were his defenders.

No effort was spared in the attempt to ensure that the event would provoke legal action and spark a confrontation which would ratify Dada's seditiousness in the eyes of revolutionary groups. Short of such an outcome, indeed, there was no hope of saving Dada.

Benjamin Péret, whose entire life was informed by an unwavering and intransigent radicalism, testified to great effect at the Barrès

trial, speaking in German and playing "The Unknown Soldier". All the witnesses, moreover, waxed eloquent upon the excremential character of veterans, of Barrès and of everything having to do with the nation and its traits. Victor Crastre is right, however, when he insists in his book *Le Drame du surréalisme* [The Tragedy of Surrealism] that the Barrès trial was a failure:

> The absence of any reaction from the right, coupled with the silence of the revolutionary parties, meant that the trial had failed. This failure was echoed by a regression to aestheticism, in the shape of the Salon Dada that opened at the Galerie Montaigne on the 6th of June 1922, and its mediocre triumph. In this connection Breton wrote: "It seems to me that the sponsorship of a series of utterly futile 'Dada' actions is on the point of very seriously compromising an undertaking to which I remain attached." This attachment would oblige Breton to try and save Dada from the sterility that was now threatening it. He decided to convene a congress in order to clear matters up: the "Paris Congress for the Orientation and Defence of the Modern Spirit". This was an ambitious project, aiming as it did to get poetry and art back onto firmer ground than the shifting sands in which they had been caught. And it did not succeed. Writers and artists who had made small reputations for themselves in and through Dada saw little reason to throw everything away for the sake of a venture which seemed to them to have no future, for they had nothing but mistrust for the "spirit" in whose name the Congress was being called.
>
> After this setback Breton and his friends scaled down their ambitions, being inclined to explore the depths while casting their net less widely. They refused all alliances. And, now much reduced in numbers, the group withdrew into itself.

It is notable that Picabia, the most consistent nihilist of the Dadaist group, lent his support to the projected Congress. By contrast Tzara opposed the idea, claiming that such a project was essentially constructive, whereas Dada was by definition pure negation!

THE SPECIFICITY OF SURREALISM

The break with Dada became utterly final in 1923, when, at a performance of Tzara's *Coeur à gaz* [The Gas Heart], the author called the police and sought to have Éluard, Breton and Péret thrown out as troublemakers.

Around a hard core made up initially of Breton, Aragon and Soupault, there now revolved an often disparate group of personalities, among them Éluard, Péret, Robert Desnos, Roger Vitrac, Max Morise, Georges Limbour, Joseph Delteil, Jacques Baron, René Crevel, Man Ray, Marcel Duchamp, and Max Ernst. 1924 and 1925 were to be the pivotal years of Surrealism: until then, the movement was detaching itself from a Dadaist spirit which it had always espoused only with reticence; afterwards, the Surrealists began to seek agreement with communists of one kind or another, from the somewhat marginal Leninists of *Clarté* to the hard-line Stalinists of the French Communist Party.

This fruitful period saw the conception and publication of Breton's *Manifesto of Surrealism*, the appearance of a review, *La Révolution Surréaliste*, and the creation of a "Bureau for Surrealist Research". The Surrealists' interest in dreams and automatic writing, the attention they paid to Freud, their invention of games, their cultivation of the *dérive* and of chance encounters, and their experiments with spiritualism—all these together constituted a unified set of preoccupations capable of shedding clear new light on human possibilities. Indeed the first issue of *La Révolution Surréaliste* proclaimed the need for "a new declaration of the rights of man".

The group was soon joined by André Masson, Mathias Lübeck, Georges Malkine, Pierre Naville, Raymond Queneau, Antonin Artaud, Jacques Prévert, Marcel Duhamel and Pierre Brasseur, while in Yugoslavia a Surrealist movement emerged whose prime mover was Marco Rititch.

At this time, too, Surrealism created a piquant genealogy for itself which included figures whose work cried out for dialectical

supersession on the plane of real life (de Sade, Lautréamont, Fourier, Marx, etc.), great dreamers (Nerval, Novalis, Achim von Arnim), alchemists (Paracelsus, Basil Valentine), a motley of impassioned, eccentric and fantastic forebears, poets of black humour, and so on—in short, a whole pantheon that was continually being added to (and occasionally reduced, as in the case of Poe, who was inducted at first, only to be expelled subsequently on account of his contribution to the science of police work). Most important of all, the group appropriated the Dadaist technique of scandal-making and turned it effectively against the representatives of official culture. Two scandals in particular may be said to have thoroughly shaken up the conventional wisdom of the time. These were the publication of the pamphlet *A Corpse*, hailing the burial of Anatole France, and the events surrounding the Saint-Pol-Roux banquet. Anatole France, as Breton explains in *Entretiens*,

> was the prototype of everything we held in contempt. In our eyes, if ever there was an undeserved reputation, it was his. The supposed transparency of his style left us cold, and his much vaunted scepticism we found repugnant. It was he who had said that "Rimbaud's sonnet 'Voyelles' [Vowels] defies common sense", even if its verses were "amusing". On the human level, we found his attitude as sinister and despicable as could be: he had done whatever one had to do to garner the support of Right and Left alike. He was so puffed up with his honours and his own self-importance that we felt no compunction whatsoever.
>
> This windbag has since been so thoroughly deflated that it is hard today to imagine the rage that those four pages, containing texts by Aragon, Delteil, Drieu la Rochelle and me, were capable of unleashing. According to Camille Mauclair, Aragon and I were nothing but "raving maniacs", and he added that "These are the manners not of upstarts and ruffians but of jackals...". Others went further, calling for legal sanctions against us.

In July 1925, a banquet in honour of Saint-Pol-Roux, who was an idol to Breton and several other Surrealists, offered the perfect opportunity to get rid of the literary trash once and for all. The French ambassador, Paul Claudel, had declared to an Italian newspaper that Surrealism, just like Dadaism, had "one meaning only—a pederastic one". The Surrealists' riposte came in the form of an "Open Letter" printed on *sang-de-boeuf* paper and slipped under each plate at the Closerie des Lilas, where the banquet took place. Breton's amused account of what ensued is well known:

> By the time a rather sad "hake in white sauce" was being served, a number of us were standing on the tables. Things fell completely apart when three of the guests went off and came back soon afterwards with the police in tow. But, as humour would have it, it was Mme Rachilde, by this time at a high pitch of agitation, who in the general chaos ended up getting arrested.

On this occasion, too, Michel Leiris was nearly lynched for shouting seditious slogans from the restaurant window at a passing veterans' parade: "Long live Germany! Long live China! Long live Abd-el-Krim!"

Anarcho-Dadaism was still a lively strand in the Surrealism of this period. For instance, the cover of the first number of *La Révolution Surréaliste* showed a photograph of the anarchist Germaine Berton amongst members of the group. But there was more provocation here than commitment, for neither Bonnot nor Ravachol were members of the Surrealist pantheon; what is worse, Mécislas Charrier would be guillotined by Poincaré without so much as a peep out of Breton and his friends. All the same, it was the ferment of revolt that they kept on the boil, and the precision with which they continued to denounce the permanent outrageousness of the prevailing organization of society (a precision still very much in evidence in the intervention in favour of Violette Nozières) that would prevent the best Surrealists from reducing their dream of a global revolution, no matter

how confused it was, to the mediocre level of Bolshevism. It was these, together with the cult of the passions, and especially of love, that saved the movement from any outright compromise with infamy. (Surrealism's passing alliance with Trotsky, the butcher of Kronstadt in 1921, may be put down to ignorance.)

IN THE SHADOW OF THE COMMUNIST PARTY

Beginning in 1924 and 1925, the feeling gradually came to prevail in the movement that its aesthetic critique needed political reinforcement. Meetings were held between the Surrealists and members of *Clarté*, among them Victor Crastre, Marcel Fourrier and Jean Bernier. This was a group of avant-garde intellectuals on the left of the Communist Party who opposed the conformism of Henri Barbusse, then literary editor of the Party newspaper *L'Humanité*.

There were many Surrealists who felt that ensuring the support, or at any rate the benevolence of the Party was a more decisive way of breaking with the *littérateurs* than merely playing the barbarians hammering at the gates of culture, a ploy which in any case ran the risk that one day those gates would give way, allowing the barbarians to pitch their tents within the citadel, and thus be co-opted. For those who felt this way, and for a few others too, the image of the Bolshevik with a knife between his teeth, much exploited by the Right, continued to be very seductive. What they did not know was that the freshest blood on that knife, fresher than that of the Whites, was that of the Makhnovists and the left opposition, and that before long it would be put to work settling all of Stalin's vendettas.

Only Artaud, ever sensitive to the merest hint of oppression, now distanced himself in clear awareness of what was at stake. As his friends moved closer and closer to *Clarté*, he stood more and more aloof, and eventually withdrew altogether. Soupault, Vitrac, Baron and a few others opted straightforwardly for literary careers at this point; they thus made their exits by the opposite door to Artaud, duly receiving Breton's farewell in the *Second Manifesto* as they departed.

In 1926 it was resolved that a new periodical entitled *La Guerre Civile* would be launched in conjunction with *Clarté*. That this plan came to naught bespeaks the fact that it was now too late for two autonomous spheres, that of a specialized politics and that of a specialized reanimated art, to fuse into one.

Surrealist activity had nonetheless never before reached such heights. The spirit of the movement was spreading internationally. In Belgium, René Magritte, Paul Nougé and Louis Scutenaire founded a Surrealist group whose inventiveness, style and violence would carry it a very long way before—much later on—it collapsed into a sophomoric humour punctuated by Stalinist professions of faith.

The game of "Exquisite Corpse", in which a poem or picture is created collectively by players who are unaware, except for the first element, of what the others write or draw, was a successful revival, with increased emphasis on language, of the spirit of Dadaist collage, of the notion of a poetry made by all, of the idea of objective chance. This pastime supplied Surrealism with one of its best and most interesting ways of satisfying its propensity for playfulness.

In 1927 André Breton joined the Communist Party. Assigned to the "gasworkers' cell", he set out with a disarming willingness to do his bit, but he was exasperated by the Communists' bureaucratic tendencies (which for the time being were not so much sinister as ridiculous), and before long he left the Party militants to their illusions.

On the Artaud side of things, meanwhile, though without any direct input from Artaud, a tendency emerged in Surrealism which would become preponderant after the Second World War. The voice of this tendency was René Daumal and Roger-Gilbert Lecomte's review *Le Grand Jeu*, whose first issue appeared in 1928. The possibility of a convergence between this group and Breton's was explored, but proved impossible. Daumal and Lecomte had little taste for the kind of discipline Breton imposed. Furthermore, they had a certain contempt for politics, this at a time when the mainstream Surrealists were hastily becoming politicized, and whenever they were reproached on these grounds, which was often, they would respond by warning of the danger of Surrealism's co-optation. The two groups had a common interest in union, but neither side felt passionately enough about its necessity for it to come about, and as soon as a pretext presented itself, they went their separate ways. That pretext was an apologia for the Prefect of Police, Chiappe, written for a newspaper by Roger Vailland, a member

of the Grand Jeu group. Daumal and Lecomte rebuked Vailland for this in the weakest of terms; Breton was not accustomed to tolerating the absence of a violent reaction to a failing of this kind. (Subsequently Daumal moved closer and closer to a Gurdjieffian position, so much so that in 1933 he broke with Lecomte.)

The *Second Manifesto*, published in 1930, became in effect a general settling of accounts. Among those expelled were Jacques Baron, Georges Limbour, André Masson, Roger Vitrac, Desnos, Prévert and Raymond Queneau. It was Artaud above all, however, who came under attack. Admittedly, he had brought anathema upon himself by calling the police on his friends when they tried to disrupt a performance at the Alfred Jarry Theatre; yet Tzara, after all, had pointed Breton and Éluard out to the police in 1923, and Breton was now reconciled with him.

During this period the Surrealist group was reinforced by the arrival of Luis Buñuel, Salvador Dalí and René Char. In Prague the movement was riding high thanks to Vitezlav Nezval, Jindrich Styrsky, Karel Teige and Toyen. In 1929 Jacques Rigaut, like Cravan and Vaché a great living exemplar of Dadaist nihilism, killed himself.

On the scandal front, the psychiatrists got up in arms over the calls to murder contained in Breton's *Nadja*, which were indeed directed at them personally. A new periodical, *Le Surréalisme au Service de la Révolution* [Surrealism at the Service of the Revolution], was launched with an appropriate aggressiveness, though the title suggested a marked retreat as compared with that of the earlier *La Révolution Surréaliste*. If Surrealism was to be in the train of a revolution whose only possible motor was the Communist Party, the fate of poetry—not to mention that of the revolutionaries—was surely sealed. Happily, the content of the new periodical tended to belie its title. Crevel, summarizing the state of play in the third issue, was able to write:

Surrealism: not a school but a movement; does not therefore speak *ex cathedra* but goes to see, goes in search of knowl-

edge, of knowledge applied to the Revolution (via a poetic route). Lautréamont had said: poetry must be made by all, not by one. Éluard's comment on this: poetry will purify all men. All ivory towers will be demolished.

And Crevel adds: "Starting out from Hegel, like Marx and Engels but following a different path, Surrealism ends up at dialectical materialism." Truth to tell, Hegel was discovered very belatedly by the Surrealists, and, even more important, they made barely any *practical* use of him—not even as a tool for discriminating between the dialectic and the thinking of a Maurice Thorez. Their taste for life made a much greater contribution, and the best of Surrealist thought unquestionably arose from their analyses of lived moments, which revealed the dialectic far better than quotations from Hegel and created poetry far more effectively than any poem.

In response to Breton's diatribes in the *Second Manifesto*, the excludees issued a violent pamphlet which emulated the tone and borrowed the title of the compendium of insults earlier directed at Anatole France: *Un Cadavre* [A Corpse]. The "Bar Maldoror"—a premature attempt at commercial co-optation—was sacked by Breton and his friends. Buñuel's film *L'Âge d'or* roused the ire of war veterans and of the Right. One particularly fine expression of anger, an open letter to the top student applicant of the year admitted to the Saint-Cyr Military Academy, exposed Georges Sadoul, one of the signatories, to a three-year prison term. And a critic at *La Liberté* called for Péret to be shot for having written the poem "Vie de l'assassin Foch" [Life of the Murderer Foch], which dealt with its subject in tones of unparalleled execration.

At this time too, Maurice Heine published his admirable preface to de Sade's *Justine*. Heine exerted a much greater influence on the Surrealist movement than his natural discretion, and that of his friends, might lead one to suppose.

In 1931 Surrealism's dalliance with the Communist Party took a militant turn. The group signed up with the Association of Revolutionary Writers and Artists, which was controlled by the

Party. Was it perhaps by way of a counterweight that at this same time research into "magical" works intensified, spurred on by the revelation of Alberto Giacometti's "objects with symbolic functions"? At all events, the links between alchemy and creative paths to new and sacrosanct relationships was very much in the forefront of Surrealist meditations even as the "Aragon affair" was bubbling up.

This affair began when Breton and his friends, though approving of neither its spirit nor its form, nevertheless took up the defence of Aragon's long poem "Front rouge" [Red Front], written during a visit to the USSR. The embarrassment Breton experienced at thus having to stand behind Aragon, whose text already contained the seeds of the paeans to the fatherland that were to follow, is quite tangible in his *Misère de la poésie* [The Poverty of Poetry].

In the meantime, Aragon was sending very optimistic reports back from Moscow concerning the prospect of the Surrealists reaching agreement with the Communists. Sadoul, Aragon's travelling companion in Russia, returned to Paris ahead of Aragon himself, who stopped off in Brussels for a few days. Here is Breton's account in *Entretiens* of the conversation he had with Sadoul on the latter's return:

> Yes, everything had gone well; yes, the objectives we had decided to set ourselves had been met, but.... There was indeed a very large "but". An hour or two before their departure, they had been asked to sign a declaration that implied the abandonment, not to say the explicit rejection, of practically every position we had held up until then. They were expected to renounce the *Second Manifesto* "inasmuch"—I quote word for word—"as it is contrary to dialectical materialism". They were supposed to denounce Freudianism as "an idealist ideology" and Trotskyism as "a social-democratic and counter-revolutionary ideology". Finally, they would undertake to submit their literary activity "to the discipline and control of the Communist Party". "And so?", I asked Sadoul brusquely. And, getting no reply, "I take it you refused?" "No," he replied, "Aragon felt that we—that is, you as well as us—would have to go along if we wanted to

work in the Party's cultural organizations." That was the first time in my life that I saw a chasm opening up before my very eyes, a chasm that has since widened dizzyingly, in proportion to the relentless headway made by the outrageous idea that truth should bow down before efficacity, that neither conscience nor individual personality are worth heeding—in short, that the end justifies the means.

In 1932 Aragon rallied to the Communist Party. The same year saw the publication of Breton's *Communicating Vessels* and one of René Crevel's finest texts, *Le Clavecin de Diderot* [Diderot's Harpsichord].

THE BREAK WITH THE SO-CALLED COMMUNIST PARTY

Breton was saddened by Aragon's lack of spine; his friends, outraged, reacted according to the tradition. Several of them produced texts lambasting the author of "Red Front". Éluard, notably, did not hesitate to write:

> What was inconsistency has become calculation; what was subtlety has become intrigue. Aragon has become other, and his memory henceforward cannot attach itself to me. To defend myself I have a sentence which between him and me can no longer have the exchange value I so long accorded it, a sentence which has never lost its meaning and effectively passes judgement on Aragon as on so many others: *All the water in the sea could not wash away a single intellectual bloodstain* (Lautréamont).

This turned out, however, to be a case of the pot calling the kettle black. A few years later, Éluard, hand in hand with Aragon, would be a fashionable figure in the Stalinist star system, ever ready to claim that the words party, fatherland and freedom rhymed to perfection. And in 1950, when Breton implored him to intervene on

behalf of an old mutual friend of theirs, Zavis Kalandra, condemned to death in Prague, Éluard (though he forgot to quote his favorite sentence) had this to say: "I am too busy with innocents proclaiming their innocence to bother with people who are guilty proclaiming their guilt." Kalandra was executed.

In 1933 the Association of Revolutionary Writers and Artists announced its first expulsion: André Breton. As Breton recalled later in *Entretiens*:

> The reason for this expulsion was that Number 5 of *Le Surréalisme au Service de la Révolution* contained a letter addressed to me by Ferdinand Alquié, a letter written in a libertarian spirit, indeed a most moving letter, in which the writer took violent exception to the civic and moral tone informing the Russian film *The Road to Life*. Regardless of the opinions Alquié expressed, not all of which I agreed with, the intensity of life and revolt distilled into his letter seemed to cry out for its publication. There was therefore no chance at all of my uttering the retraction that was being demanded of me.

The following year a Surrealist group appeared in Egypt, with Georges Hénein as its prime mover. In Brussels, *Documents 34* published a special issue on "Surrealist Intervention" which included a number of contributions remarkable for their violence and uncompromising attitude. 1934 was above all the year of the Surrealists' hommage to Violette Nozières. In this young parricide, who had been condemned to death, the Surrealists saluted a symbol of active resistance to oppression by the family. It is hard, though, to explain the failure of the group to raise a similar cry in support of the Papin sisters, servants who around the same time illustrated Swift's *Directions to Servants* after their own fashion by murdering their mistress and her daughter. It is true that by this time political events were fast gathering momentum.

Relations between the Surrealists and the Communist Party leadership grew ever more hostile. An incident in 1935 was to bring

these relations to an end once and for all. About ten o'clock one night, shortly before the opening of the Congress of Writers for the Defence of Culture, a Stalinist-run event, Breton ran into Ilya Ehrenburg on the Boulevard du Montparnasse. Once again we may rely on Breton's account in *Entretiens*:

> There was a passage I was not ready to forget in a book of Ehrenburg's, *Vus par un écrivain de l'U.R.S.S.* [Observations of a Soviet Writer], which had appeared a few months earlier. Among his remarks therein were the following: "The Surrealists are all for Hegel, all for Marx, all for the Revolution. What they are absolutely against, however, is work. Not that they do not have their occupations. They study pederasty and dreams, for example.... They keep themselves busy consuming their inheritances and dowries...." And so on. So, after identifying myself, I slapped him several times, while he tried pathetically to palaver with me without so much as raising his hand to protect his face. I fail to see what other revenge I could have taken on this confirmed slanderer....

On the eve of the Congress, after exhausting discussions with the organizers over their refusal to let Breton address the gathering, René Crevel took his own life. This gesture, just like Artaud's solipsism, constitutes an immediate, spontaneous, negative response to the problem that Surrealism had posed—a false problem, in fact, because its basic assumptions were false. For how was it conceivable, on the basis of independent sectors already objectively stripped of all human values by the depredations of the spectacular-commodity system, on the basis of activities which, though in fact partial, were promoted as totalities (as art, politics, thought, the unconscious, survival, etc.) and presented as positive—how was it conceivable that on such bases any unity of the individual, either within himself or with respect to others, might be achieved? How could Surrealism, while ignoring the Dadaist quest for total negativity, expect to provide any historical foundation for the positivity and global transcendence to which it aspired?

27

The Surrealists denounced the Moscow trials. They moved closer to Georges Bataille, whose Contre-Attaque movement defined itself as "a combat group of revolutionary intellectuals opposed to fascism". In Tokyo a Surrealist review was started by Yamanaka. In London Roland Penrose mounted a major exhibition. Benjamin Péret published *Je ne mange pas de ce pain-là* [I'd Rather Starve]—poetry genuinely searching for adequate practical expression with its call for the liquidation of army, police, priests, bosses, money, work and all other forces of brutalization. Péret, who had the courage of his convictions, enlisted with the anarchists in the Spanish Revolution. He was the only Surrealist to participate directly in that struggle; all the others supported the cause enthusiastically, but from afar.

Pictorial concerns, which seemed to come back to the fore after the break with the Communist Party, did not override the Surrealists' continuing embrace of a lesser-evil approach to politics, and before long they rallied to Trotsky and the Fourth International: on a visit to Mexico in 1938, Breton published the manifesto "For an Independent Revolutionary Art" in collaboration with Diego Rivera and the author of *The Crimes of Stalin*.

Dalí's imbecilic games had finally palled, and he was expelled from the group in 1939. He was thus completely free to develop a "technique", blending obscurantism with the symptoms of dementia praecox, which to this day continues to provide fertile soil for the avant-gardists of the advertising world. Despite the anagrammatic nickname of "Avida Dollars", used by Breton to castigate him, Dalí at least had the merit, in his shameless pursuit of money, contracts and honours, of openly treating art works as commodities— something which the Ernsts, the Mirós, the Picassos and all the other Surrealist artists, whether they were talented or not, did only shamefacedly.

Breton now made up with both Artaud and Prévert. Nothing, really, should ever have induced them to part company. Prévert and Péret were cut from the same cloth, and in Breton, albeit strictly con-

trolled, there was a good deal of Artaud. These four waged unceasing war on Surrealism as ideology, on the growing co-optation of the movement. Unfortunately Surrealism had been an ideology in the profoundest sense from the beginning; it was always doomed to be part of the game of old and new in the cultural sphere—and could have avoided this destiny only if, say, the Spanish Revolution had triumphed over both the Stalinists and the fascists and hence made possible a transformation of Surrealism into revolutionary theory. Unaware of this, or refusing to accept it, Artaud, Breton, Péret and Prévert fought to the glorious strains of what sounded very much like a song of defeat. They were the last formation of four, and, having nothing more to lose, they never surrendered.

On the other hand, Salvador Dalí adopted Surrealism at its most ideological on a full-time (and full-space) basis. He espoused fascism, Catholicism or Franco just as Aragon had espoused Stalinism. Éluard took the same road as Aragon. As Breton recalls in *Entretiens*:

> When I learnt, in Mexico City, that poems of Éluard's had just appeared in *Commune*, which was the magazine of the "Maison de la Culture", I naturally hastened to inform him about the unspeakable methods those people had used against me, nor did I doubt for a second that he would immediately distance himself from them. But I had no reply from Éluard, and upon my return I was stupefied to hear him claim that a collaboration of this kind in no way implied any particular commitment on his part, and indeed that in the last few months he had contributed, just as willingly as to *Commune*, to various fascist publications (these are his words, not mine) in Germany and Italy. I confined myself to the observation that this attitude of his amounted to a rejection of any kind of agreement that we had ever reached between us and made any further meeting pointless.

In 1940 the deaths of Paul Klee, Maurice Heine and Saint-Pol-Roux—three non-Surrealists who nevertheless left a deep impression

on the movement—in a way marked the end of Surrealism's great period. Breton, it is true, would still have much to say, as would Péret, but from now on these two would be virtually alone as they strove to keep things going. In the summer of 1941 Breton disembarked in New York, soon to be joined by Ernst and Masson. Péret chose Mexico.

The only Surrealism known in the United States was the "Avida Dollars" version. With help from Marcel Duchamp, Breton contrived to produce a review, *VVV*, in which he published "Prolegomena to a Third Surrealist Manifesto or Not" (1942).

POST-WAR YEARS

After 1945 Surrealism began firing its last salvoes. It lived on without achieving clearer definition. The movement turned its attention in a more determined manner towards mysticism and alchemy, while its political effusions betrayed growing confusion and vapidity. In 1946 the pamphlet *Liberté est un mot vietnamien* [Liberty Is a Vietnamese Word] protested against French repression in Indochina. *Inaugural Break* (1947) was a denunciation of Stalinism—though in 1956 the Surrealists would express the hope that after the Khrushchev speech at the Twentieth Congress of the Soviet Communist Party a new broom would be applied to the party apparatus. No sooner had they dispensed this considerate advice, however, than they found themselves obliged to hail the Hungarian uprising in *Hongrie, soleil levant* [Hungary: The Sun Rises].

In 1960 Surrealists were the initiators of the "Declaration on the Right of Conscientious Objection in the Algerian War"—the so-called "Declaration of the 121". Eight years later, whatever residue still went by the the name "Surrealist" was singing the praises of Cuba!

Along the way the Surrealists worked with the anarchists of *Le Libertaire*, and for a time supported Garry Davis's Citizens of the World movement.

Before the war the review *Minotaure* had been the last real melting pot of Surrealist ideas. Its successors in the post-war world, *Néon* (1948-49), *Médium* (1953-55), *Le Surréalisme, même* (1956-59), *La Brèche* (1961-65), *Bief* (1958-60), and *L'Archibras* (1967-69) bear increasingly brutal witness to the decay of the movement.

Important Surrealist works did appear in the post-war years; unfortunately they were overshadowed by the fashionable but dismal elucubrations of the likes of Sartre, Camus or Saint-Exupéry. These works included Breton's *Anthologie de l'humour noir* [Anthology of Black Humour], banned by the Vichy government in 1941 and barely noticed in 1945; *Le Déshonneur des poètes* (1944), in which Péret hauled Aragon, Éluard and the other patriot-poets over the coals; Breton's *Arcanum 17* (1945), a lyrical meditation on sensibility, love and poetry, his very beautiful *Ode to Charles Fourier* (1947), and his *Flagrant Délit* [Caught Red-Handed], which exposed a fraudulent attribution of poems to Rimbaud, condemned the imbecility of literary critics in general, and heaped scorn on Maurice Nadeau, author of a *History of Surrealism*; Péret's *Anthologie de l'amour sublime*, with its extraordinary profusion of linguistic fireworks; the novels of Julien Gracq and Maurice Fourré; Malcolm de Chazal's *Sens plastique*; and Jean Markale and Lancelot Lengyel's studies on Celtic art.

Apart from such personal works, however, Surrealism now displayed a great tolerance for rehashes, for mere imitation of the masters, for sorry expressions of mutual admiration. Many Surrealists made their peace with the incoherence of the dominant system. Others fell silent. Yet others followed the example of Crevel and committed suicide— indeed, the decline of Surrealism, the last movement to have held a genuine belief in the purity of art, is peppered with suicides, among them those of the painter Arshile Gorky (1948), the painter Oscar Domínguez (1957), the poet Jean-Pierre Duprey (1959), the painter Wolfgang Paalen (1959), as well as that of Karel Teige, who killed himself in Prague as the police were coming to arrest him.

A pamphlet published on 7 June 1947 by the Revolutionary Surrealists, a dissident Belgian group, had issued a salutary warning

to the movement as a whole. Signed by Paul Bourgoignie, Achille Chavée, Christian Dotremont, Marcel Havrenne, René Magritte, Marcel Mariën, Paul Nougé and Louis Scutenaire, it declared:

> Landlords, crooks, Druids, poseurs, all your efforts have been in vain: we persist in relying on SURREALISM in our quest to bring the universe and desire INTO ALIGN-MENT.... First and foremost, we guarantee that Surrealism will no longer serve as a standard for the vainglorious, nor as a springboard for the devious, nor as a Delphic oracle; it will no longer be the philosopher's stone of the distracted, the battleground of the timid, the pastime of the lazy, the intellectualism of the impotent, the draft of blood of the "poet" or the draft of wine of the *littérateur.*

But, as though to give the true measure of their protest, and certainly exemplifying the grotesquerie which would thenceforward dog Surrealism in its dotage, the aforesaid signatories declared without further ado that they placed their entire faith in the Communist Party!

CHAPTER 2

CHANGING LIFE

THE REFUSAL OF SURVIVAL

It is significant that the first *Manifesto of Surrealism* starts out by denouncing that mode of existence which, to distinguish it from passionate and multidimensional *life*, has been called "survival":

> So strong is the belief in life, in what is most fragile in life—
> *real* life, I mean—that in the end this belief is lost. Man, that
> inveterate dreamer, daily more discontent with his lot, has
> trouble assessing the objects he has been led to use, objects
> that his nonchalance has brought his way, or that he has
> earned through his own efforts, almost always through his
> own efforts, for he has agreed to work, at least he has not
> refused to try his luck (or what he calls his luck!). At this
> point he feels extremely modest: he knows what women he
> has had, what silly affairs he has been involved in; he is
> unimpressed by his wealth or poverty, in this respect he is a
> newborn babe and, as for the approval of his conscience, I
> confess that he does very nicely without it.

The only thing absent from Breton's tableau of intolerable mediocrity is history. No doubt the nostalgia for the "château life" which always haunted the Surrealist dream contained an implicit reference to the great myth of the unitary society of old, where the individual trajectory of even the humblest of men was inextricably bound up with the cosmic in a mass of fictional realities and real fictions, an atmosphere in which every event was a sign and every word or gesture magically sparked off mysterious currents of mental electricity. The collapse of this myth, and its subsequent co-optation as spectacle by the bourgeoisie, were never successfully analysed by Surrealism. In the end the Surrealist movement never did more than echo the kind of furious foot-stamping which, from Romanticism to Dada, had been the sole response of artists thwarted by the demobilizing combination (supplied courtesy of the commodity system) of a lifeless soul and a soulless life. Romantic rebellion from Shelley to Karl Sand and Pierre-François Lacenaire had given way to the aggressive aestheticism of

35

Villiers de l'Isle-Adam and the plunge into Symbolism, into the mannerism of the theatrical transposition of decadence and death. The bloody comic opera of the Great War was to lend real content to the macabre imaginings of a Rollinat or a Huysmans, as likewise to those baroque décors which paradoxically expressed a taste for great refinement. Nationalism thus contrived to crown the sorry festivities of the fin de siècle with the apotheosis of a great feast of the dead. A few million corpses quickly revived the taste for life. And when the proletariat rediscovered its voice, and the voice of history, in the shape of the call for soviets and the Spartacus movement, the greatest hopes were justified regarding the prospects for a radically different life, for the creation of the only conditions capable of underpinning such a life: the abolition of the commodity system and of bourgeois-Christian civilization.

Dada had not been mistaken about this, though some Dadaists erred less than others. Breton was likewise correct in 1922, in the fifth issue of *Littérature*, when he wrote: "In fairness to Dada it must be acknowledged that, had its strength not failed it, it would have wanted nothing better than to destroy everything *from top to bottom.*" Yet in general the Surrealists grasped even less clearly than the Dadaists to what degree and in what sense the sailors of Kiel, the Spartacist workers or the members of the first Russian councils were putting into practice the same project that they themselves nurtured.

Once revolution had been crushed from Berlin to Kronstadt, via La Courtine and the plains of the Ukraine, Dada alone continued to demand, unabashedly if confusedly, the global destruction of art, philosophy and culture as separate spheres and their *realization* in the context of a unitary social life. The guilty conscience of Surrealist reformism is testimony to this global revolutionary project, which the movement rejected only with great reluctance and indeed continued to embrace in a repressed form.

Thus Breton was quite able to proclaim, in Number 4 of *La Révolution Surréaliste*, that "There is no such thing as a work of art that can withstand our total primitivism", and Aragon could evoke "the paltry political activity that has occurred to the East of us over the

last few years". Though both these remarks are accurate enough, the first bespeaks someone who is still lacking in consciousness, the second someone who is already an imbecile. The sequel was to demonstrate, in any event, that these were merely words without practical consequences. The Dada spirit outlived itself as an empty verbal form; Surrealism surreptitiously endowed that form with another content.

All the same, the melancholy of everyday life was the stirrup that enabled Surrealism to take its wild ride through the world of dreams. Contrary to the prognostications of not a few Stalinist thinkers, the movement was not destined to serve simply as a trampoline for escapism and mysticism. On the contrary, it became that focus of despair whence all new hope derives, even if the road taken was the cultural one.

Arthur Cravan and Jacques Vaché, two great witnesses to *mal de vivre*, were soon to die. The first put out to sea one stormy evening on the Gulf of Mexico; the second, who had written from the front that it was "tiresome to die so young", killed himself in Nantes no sooner than the War was over. Soon after there would be Jacques Rigaut and Raymond Roussel and, among the Surrealists, René Crevel. Like Artaud, Crevel had been struck by the predominance of non-life in the totality of human affairs, and it was he who, in a text on Paul Klee, voiced a sentiment that the Surrealists would have done well to pursue further: "We care neither for the asparagus of the poor nor for the leeks of the rich."

Dada held up a mirror to survival as an absence of real life and as a directly apprehended reality, thus "making its shame more shameful"; suicide constituted a condemnation, by way of the negative, of survival's logic of death.

Being an ideology, Surrealism was a strictly static vision whose impression upon history could never surpass the weight which history itself accorded it (as distinct from revolutionary theory, which starts out from history, then returns to history and moves it forward); for Surrealism, survival, suicide and death were the starting point which life was supposed to negate, but which it could not transform without first achieving a state of "absolute deviation". This was the

metaphysical conundrum from which the Surrealists were trying to escape when they mistakenly pinned their hopes on Bolshevism.

That is why the first issue of *La Révolution Surréaliste* is replete with press clippings concerning suicide. In the survey conducted in that issue on the question of why people kill themselves, Artaud's response remains exemplary:

> I suffer frightfully from life. There is no state I cannot attain. And without a doubt I have been dead for a long time already—I have already committed suicide. I have, as it were, been suicided. But what would you think of a suicide before the fact—a suicide that made you redirect your steps, but to somewhere beyond being, not towards death.

Artaud's path was already quite clear. Through a nihilism that Dada never attained, though it had sought it as a basis on which to reconstruct the self, life, and social organization, Artaud chose a return to the dissolution of the self in a spiritual totality. The Surrealism of the years after the Second World War would adopt a comparable stance, returning in this way to the movement's starting point, and even transcending it, but it nevertheless avoided the lucidity and the drama lived out by Artaud. Very few Surrealists would ever apprehend their own alienation with Artaud's courage and awareness: "I am unhappy like a man who has lost the best part of himself." Very few would face up so directly to their own fragmented state: "I no longer want to be one of the deluded. Being dead, others are not separated from themselves. They continue to circle around their own corpses. As for me, I am not dead, but I am separated from myself."

For Artaud, in 1924, the hope of a classless society, the hope of a coming reign of freedom, so passionately entertained by Surrealism, had already been dashed. Later, when the unmasking of Stalinism cast a dark cloud over these aspirations in the hearts of Breton and his friends, Surrealism embraced Artaud's conclusion in an *intellectual* way, and resolved like him to live the drama of every-

day alienation as a cosmic tragedy of the mind.

In 1924, though, Surrealism was nowhere near that point. Its survey of suicide also addressed the question of life. To the possibility of death were quickly attached all the possibilities of freedom and all the freedoms of the possible. As Breton put it,

> It is remarkable how these replies, be they subtle, literary or derisive, all seem so arid; why is it that no human resonance is detectable in them? *To kill oneself*—has no one weighed the fury and experience, the disgust and passion, that are contained in this phrase?

Surrealism thus recognized the mark of the old world and its oppressive structures in the inhumanity of survival. Though it may have displayed a singular lack of discernment with regard to the ramifications of commodity fetishism, it must still be given credit for having so very rarely failed to measure up (as Breton was wont to say) to the revolutionary ethic of freedom. The Surrealists' denunciation of oppression was well-nigh continual, and the violence of their tone cannot help but arouse our sympathy.

The fact remains that these young people, who ought by rights to have turned themselves into theorists and practitioners of the revolution of everyday life, were content to be mere artists thereof, waging a war of mere harassment against bourgeois society as though it fell to the Communist Party alone to mount the main offensive. It thus came about that targets of great moment were chosen without any deep conviction that they ought to be designated as spheres of oppression towards which the proletariat's anger should be directed; indeed many a flaming brand hurled by the Surrealists amounted to little more than pyrotechnics.

The struggle against Christianity, for instance, by now abandoned by Bolshevism, suffered not a little from this misconceived modesty. Apart from the anodyne imagery of Clovis Trouille, and Max Ernst's Virgin spanking the infant Jesus with her halo, Surrealist painting eschewed the theme altogether.

Responding to an attempt to annex him (by means, no doubt, of one of those miracles for which the Christians are so renowned), Artaud offered the following unambiguous and definitive answer: "I shit on the Christian virtues and on whatever it is that does duty for them among the buddhas or the lamas" (*Histoire entre la groume et Dieu* [History between Grousing and God]). Ever faithful to his photograph in *La Révolution Surréaliste*, which bore the caption "Our Contributor Benjamin Péret Insulting a Priest", Péret did much to rescue modern poetry from its tinkliness, and re-endow words with the promise of action, when he wrote such lines as these, from "Le Cardinal Mercier est mort":

> *Cardinal Mercier mounted on a policeman*
> *you looked the other day like a dustbin spilling over*
> > *with communion wafers*
> *Cardinal Mercier you stink of god as the stable stinks of dung*
> > *and as dung stinks of Jesus*

Or these, from "La loi Paul Boncour" [The Paul Boncour Law]:

> *Men who crush senators like dog turds*
> *looking each other straight in the eye*
> *will laugh like mountains*
> *will force the priests to kill the last generals with their crosses*
> *and then using the flag*
> *will massacre the priests themselves by way of an Amen*

The bases of a practical approach to religion were laid down in *L'Action immédiate* by René Magritte, E.L.T. Mesens, Paul Nougé, Louis Scutenaire and André Souris:

> We are convinced that what has been done to oppose religion up to now has been virtually without effect and that new means of action must be envisaged.
> At the present time the Surrealists are the people best fitted to undertake this task. So as not to lose any time,

we must aim for the head: the outrageous history of religions should be made known to all, the lives of young priests should be made unbearable, and all sects and organizations of the Salvation Army or of the Evangelical variety should be discredited by means of every kind of mockery our imagination can devise. Think how exhilarating it would be if we could persuade the better part of our youth to mount a well prepared and systematic campaign of disruption of church services, baptisms, communions, funerals and so on. Meanwhile roadside crosses might usefully be replaced by images promoting erotic love or poetically eulogizing the natural surroundings, particularly if these happen to be grim.

In an article published in *Intervention surréaliste* (1934) which went scandalously unheeded, Pierre Yoyotte set the tone for a debate that ought by rights to have sparked action of the broadest scope:

The Communists have always officially evinced an extremely unintelligent suspicion with respect to the discoveries of psychoanalysis, discoveries which would in fact have allowed them to combat the emotional processes associated with family, religion and fatherland in a completely informed manner.

Though hardly a response adequate to the seriousness of this project, René Crevel's delicious psychoanalytical account of Jesus in *Le Clavecin de Diderot* (family and neuroses/family of neuroses/family neurosis) is well worth quoting:

As the masochistic little chickabiddie of the Father Eternal, much given to turning the other cheek, Jesus was not the sort to be satisfied by some brisk return visit to the mother's breast.
On the contrary, he had to go back up into the most private of the genital parts of the genitor, to become one of those parts himself—the right testicle, say—because the Trinity may be, indeed must be interpreted as the tripartite

assemblage (in appearance) of the male sexual apparatus: a banana and two mandarin oranges, perhaps—since the Oriental style insists on fruit similes only.

True, the apotheosis of masochism is preceded by a number of smaller diversions, by what the French call diddlings at the door: baptismal badinage with Saint John the Baptist, intimate grooming with perfumed oils at the hands of saintly women, and, above all, the Last Supper with its loaves (long loaves, that is, whose meaning we all know; we also know that not one of the painters who have represented this meal in so many celebrated pictures has ever put on the table the little split loaves that commonly symbolize the sex of the woman).

Dressed in a most elegant white robe, bent under the weight of his cross, Jesus offers his back to whatever blows might be forthcoming. As soon as Pontius Pilate has washed his hands of the accused, the sexual symbolism becomes crystal-clear. Jesus falls, then gets up again: in other words, he has come, and is ready to come again under the whips of the athletic types with their skimpy costumes.

And, just as the young newly-wed wife calls for her mother, so frightened is she so of voluptuous pleasure, so Jesus continually calls out for his father.... Then comes the vinegar-soaked sponge, signalling the contempt of the handsomest of Jesus's ruffianly guards for this tatterdemalion yearning to be his pretty boy. In other words, the legionary in question, who can hardly have failed to spot the practised hips of Mary Magdalene among the whores crowding around the foot of the cross, flatly refuses to pay Jesus the hommage of even the tiniest drop of seminal fluid, and in effect pisses in his mouth to underline the point. So ... no more threesomes. Between the two felons all that remains are two chestnuts—the former juicy divine oranges have shrivelled into a pair of pitiful dried-up conkers, and the Christ is just a pathetic empty vessel.

Before leaving the subject of the critical avenues which were suitable for exploration by Surrealism in its revolutionary specificity,

but which were barely entered upon in practice, it is worth citing one quite exemplary demonstration of the popular character of anti-Christian feeling. The Communist paper *L'Humanité* having reported how a church in flames had been saved thanks to the courage of a few young people, a reader sent a letter of protest to the editors that was published in Number 2 of *Le Surréalisme au Service de la Révolution*:

> Dear Comrades, I cannot but deplore your reporter's praise for the courage of a group of young people when the only result of that courage was the preservation of a building that should by rights have been razed long ago.

After Christianity, and setting aside capitalism, with regard to which the Surrealists espoused Lenin's arguments, the chief target of execration was the family. The trial of Violette Nozières, who had murdered her father, the engine-driver of the presidential train, after he tried to rape her, offered the Surrealists the perfect opportunity to voice their views on this question. The young parricide inspired some of Éluard's sincerest lines:

> *Violette dreamed of undoing*
> *And did undo*
> *The frightful viper's nest of blood ties*

Another emblematic figure, gleefully pounced on by Péret, was the prodigiously fertile "Mother Cognacq":

> *Alas she has croaked Mother Cognacq*
> *croaked just like France*
> *From her belly green as a pasture*
> *swarmed record-breaking broods*
> *and for each new arrival*
> *they got a stoker's shovel*

No more Mother Cognacq
No more babies coming after eighteen others
every Easter or Christmas
to piss in the family cooking-pot
She has croaked Mother Cognacq
So let's dance let's dance in a ring
round her grave with a turd on the top

Péret was the most enthusiastic member of the group when it came to pouring scorn on the fatherland—on France, on Gallic avariciousness, on the cops and the army. In this vein he produced many eminently quotable lines, among them this one, from "Briand crevé" [Briand Has Croaked]: "Finally this parboiled sperm sprang forth from the maternal whorehouse with an olive branch stuck up his arse...". Or these, from "La Stabilisation du franc":

If the pigs' ears quiver
It is because "La Marseillaise" is being sung
Come on children of the shit bucket
Let's fill Poincaré's ear with our snot

And let us not forget two classics, "La Mort heroïque du lieutenant Condamine de la Tour"—

Rot Condamine de la Tour
With your eyes the Pope will make communion wafers
for your Moroccan sergeant
and your prick will become his brigadier's baton
Rot Condamine de la Tour
Rot you spineless shit

—and "Epitaphe sur un monument aux morts de la guerre" [Epitaph on a Monument to the War Dead], which Péret entered in the literary contest of the Académie Française:

The general told us
with his finger up his bum
The enemy
is that way Move out
It was for the fatherland
So off we went
with our fingers up our bums

In Breton it is possible to find the somewhat scattered makings of a libertarian position. A footnote in the first *Manifesto of Surrealism* is particularly suggestive in this regard:

Whatever reservations I may be allowed to make concerning responsibility in general and the medico-legal considerations which determine an individual's degree of responsibility—complete responsibility, irresponsibility, limited responsibility (sic)—however difficult it may be for me to accept the principle of any degree of responsibility, I would like to know how the first punishable offenses whose Surrealist character is clearly apparent will be *judged*. Will the accused be acquitted, or will he merely be given the benefit of the doubt because of extenuating circumstances? It is a shame that the violation of the laws governing the press is today scarcely punished, for otherwise we would soon see a trial of this sort: the accused has published a book which is an outrage to public decency; several of his "most respectable and honorable" fellow citizens have lodged a complaint against him, and he is also charged with slander and libel; there are also all sorts of other charges against him, such as insulting and defaming the army, inciting to murder, rape, etc. The accused, moreover, wastes no time in agreeing with the accusers in "stigmatizing" most of the ideas expressed. His only defence is claiming that he does not consider himself to be the author of his book, said book being no more and no less than a Surrealist concoction, which precludes any question of merit or lack of merit on the part of the person who signs it; further, that all he has

done is copy a document without offering any opinion thereon, and that he is at least as foreign to the accused text as is the presiding judge himself.

What is true for the publication will also hold true for a whole host of other acts as soon as Surrealist methods begin to enjoy widespread favour. When that happens, a new morality must be substituted for the prevailing morality, the source of all our trials and tribulations.

This last paragraph is truly extraordinary in its implications. To describe every act condemned by law as Surrealist would serve in the first instance to point up the universality of alienation, the fact that people are never truly themselves but rather that everyone acts for the most part in accordance with the inhuman tendencies instilled in them by social conditioning. It would then become a simple matter, when considering acts that were "reprehensible" from the standpoint of the law, to distinguish clearly between those which indeed obey a logic of death, the logic of inhumanity imposed by the powers in place, and those which by contrast flow from a reflex of the will to live. It is thus surprising on the face of it that Breton should ever have been embarassed when reminded of his celebrated proposition in the *Second Manifesto*:

The simplest Surrealist act consists in dashing down into the street, pistol in hand, and firing blindly, as fast as you can pull the trigger, into the crowd. Anyone who, at least once in his life, has not dreamed of thus putting an end to the petty system of debasement and cretinization in effect has a well-defined place in that crowd, with his belly at barrel level.

This was a quite adequate explanation, after all, of why such an act would simply be a way of making all the workings of an economic and social system which kills human beings by reducing them to the state of objects clear and comprehensible to everyone. For it is true not only that the criminal is not responsible, but also that the hierarchical organization of society, with its batteries of flunkeys—its

magistrates, cops, managers, bosses and priests—is itself fully responsible for all the acts that it condemns. But this negative aspect escaped Breton—and consequently he was unable to grasp the positivity involved either. The point of transcendence here was, nonetheless, obvious to him, and he immediately adds a rider:

> The justification of such an act is, to my mind, in no way incompatible with the belief in that gleam of light that Surrealism seeks to detect deep within us. I simply wanted to bring in here the element of human despair, on this side of which nothing would be able to justify that belief. It is impossible to give one's assent to one and not to the other. Anyone who should pretend to embrace this belief without truly sharing this despair would soon be revealed as an enemy.

While it is true that extreme despair may arouse limitless hopes, the real site of the struggle still has to be made clear. Once we have arrived at the sort of despair that impels us, following the logic of death that power imposes, to open fire into the crowd, there is only one way beyond this predicament, and that is the liquidation of power in the name of a dialectic of life and of all the hope life embodies. Having reached that point, it behoved Surrealism, as a mirror held up to the power of death, to inaugurate an anti-Surrealism capable of combining in a single practice the struggle against all forms of oppression and the defence of every positive spark thrown up by everyday life.

On such a project, which the Situationists clearly formulated in the early 1960s, the Surrealists possessed but a few scattered insights, and the only cohesion they could achieve here was a lyricism endowing these fragments with an illusory unity.

Here is Breton on Violette Nozières:

In face of your sex winged like a flower of the Catacombs
Students old fogeys journalists rotten bastards fake revolutionaries
 priests judges
Wanking lawyers
Know full well that all hierarchy ends here

When all is said and done, however, poetry as incitement to practice, and in this instance as action directed towards the abolition of the bourgeois order, is far more apparent in Breton's diatribe against psychiatrists in *Nadja*:

> I know that if I were mad, after several days of confinement I should take advantage of any lapses in my madness to murder anyone, preferably a doctor, who came near me. At least this would permit me, like the violent, to be confined in solitary. Perhaps they'd leave me alone.

FRAGMENTS OF A PROJECT OF
HUMAN EMANCIPATION

Any attempt at a total revolution of everyday life is condemned to failure and fragmentation if it does not embody a coherent and global negative critique. What is more, such theoretical and practical inadequacy means that authentic desires for freedom are rendered abstract by ideology, even though they may continue to manifest themselves in the shape of an illusory will to transcendence at the ambiguous level of language.

There is thus a trace, in the Surrealists' striving to circumscribe exceptional or disturbing occasions in lived experience, of a theory of passionate moments. "I pay no heed to the empty moments of my life," wrote Breton, and indeed his entire work revolves around intensely experienced instants. These he celebrates with a lyricism which by no means excludes their critical analysis, but which, since it fails to incorporate them into a generalized social practice, succeeds only in sealing them in the amber of aesthetic emotions. The verbal always carries the day, and, sadly, the only consistency attained by Surrealism was that of its self-justification in cultural terms. These revolutionaries of the heart were fated to carry out their revolution solely in the realm of the mind.

The points at which the old world was crumbling were eminently perceptible to the Surrealists, and they surrounded these areas with an aura that lent them a certain omnipotence. Moments of love, encounter, communication, subjectivity—all were allegedly unified by a shared quality of freedom, yet in reality they remained *isolated* so long as no heed was being paid to the fact that liberation as a material force cannot be detached from the overall emancipation of the proletariat; so isolated, indeed, that not a single Surrealist resisted the temptation to turn one or another of them into an absolute, so creating an illusory totality.

Love in particular (and justifiably so) was the object of Surrealism's most firmly and consistently sustained hopes. Presenting

the "Inquiry" into love in Number 12 of *La Révolution Surréaliste* (1929), Breton wrote that "If there is one idea which to this day seems to have escaped every attempt at reduction ... it is, we believe, the idea of *love*, alone in its capacity to reconcile every man, temporarily or not, with the idea of life." On every occasion, and at every stage, the Surrealists invoked the desired unity of poetry, love and revolt. "There is no solution outside of love", proclaimed Breton over and over again. Yet, since he had failed to understand that as part of the same process there is no love without a revolution of everyday life, Breton ended up, via the notion of "mad love", promoting a veritable cult of Woman. The Surrealists opposed libertinism in the name of an elective and exclusive form of love, but it is an open question whether these two antagonistic attitudes do not in the end amount to much the same thing, whether a woman elevated to the rank of the Chosen One and a woman fucked lovelessly are not both being treated as objects. Be that as it may, neither Breton nor Péret ever changed their minds, no matter how closely they studied Fourier and his detailed theories on this subject.

De Sade offers a pertinent counterweight to the hint of Romanticism in this conception of love. Marcel Mariën is right to point out, in his *Les Poids et les mesures* [Weights and Measures], that we should thank the Divine Marquis for "so judiciously enlightening us as to the reality of our nature and for providing us with a basis for understanding love". Likewise René Char, in the second issue of *Le Surréalisme au Service de la Révolution*: "De Sade's legacy is a love at long last cleansed of the muck of the celestial, with all the hypocrisy exposed and exterminated: a legacy capable of preserving men from starvation and keeping their fine stranglers' hands out of their pockets." Nevertheless, no matter how often they denied it, the Surrealists were continually (and curiously, for readers of de Sade) drawing the Christian distinction between carnal and spiritual love. Here, once again, the point of view of real practice was never grasped. What could be more Sadean than the dialectic of pleasure in its dual relationship to love on the one hand and insurrection on

the other? Even the nihilist Jacques Rigaut acknowledged that any reconstruction of love must follow this path: "I have ridiculed many things. There is only one thing in the world that I have never been able to ridicule, and that is pleasure."

Now it is true that the very same Péret who compiled a superb anthology of "sublime love" also wrote the ejaculatory poems of *Rouilles encagées* [Caged Rusts—meaning *couilles enragées*, or "raging balls"—*Trans.*]. But where exactly do the two objects of celebration involved here really come into conjunction? That the practical activity of individuals within the Surrealist milieu somehow guaranteed a unity of this kind is a distinctly dubious proposition. Breton, supposed standard-bearer of every freedom, was quite capable of the bald assertion, uttered during a public debate on the issue, that he "found homosexuals guilty of begging human tolerance for a mental and moral shortcoming that tends to set itself up as a system and paralyse every undertaking of the kind for which I have any respect". And he proceeded to confess, after deigning to pardon Jean Lorrain and (nothing loath!) de Sade, that he "was quite prepared to be an obscurantist in that particular area". This way of promoting a personal distaste to the level of a general law or principle (Breton even threatened to walk out of the meeting if the discussion of homosexuality was not abandoned) clearly bespeaks the worst kind of repressive attitude. During the same debate the author of *Mad Love* evinced deep hostility to the idea of a man making love with two women at the same time. If this was Surrealism's way of according all power to passion, it would hardly take a Fourier to describe it as a very rocky road.

Subjectivity, which Surrealism simultaneously obscured and illuminated, is one of those fragmentary spheres whose flights of lyricism may mask their failure to evolve into revolutionary theory. The very first issue of *La Révolution Surréaliste* quoted Pierre Reverdy's credo according to which "The poet must seek the true substance of poetry everywhere within himself." And throughout his work Breton repeatedly emphasizes the irreducible aspect of each individual, the

magic of the surrender to chance, the pursuit of adventure real or imaginary, and the revelation of unsuspected desires. "In order to remain what it ought to be, namely a conductor of mental electricity, poetic thought must in the first place be charged up in an isolated environment", writes Breton, while Georges Bataille maintains that "Surrealism is precisely that movement which strips the ultimate interest bare, emancipating it from all compromise and resolutely casting it as caprice pure and simple." Yet neither this prescription of Bataille's nor Breton's meditations on chance (which Nietzsche defined as "yourself bringing yourself to yourself") opens the way to a practical investment of the riches of subjectivity in the collective struggle for the total liberation of the individual. Thus subjectivity and its demands, acknowledged but not realized on the social plane, became a source of artistic inspiration and a measure of expressive value, but nothing more. Nothing more, in sum, than that celebrated "inner necessity" which Kandinsky held to be the one essential determinant of all creation.

Primacy accorded subjectivity in the cultural realm led to the call for a new "way of feeling", a notion that a curious figure like Lotus de Païni would successfully nurture in response to the general enervation of the senses, of thought and of sensation. The Grand Jeu group went ahead of the Surrealists down the mystical road which conflated subjectivity not only with the new way of feeling but also with the myth of old. This was what René Daumal called "the turning back of Reality towards its source", and it focused all hopes on the point described by Breton as follows: "Everything tends to suggest that the mind may reach a point whence life and death, real and imaginary, past and future, communicable and incommunicable, and high and low, all cease being perceived as contradictory." So long as it remained detached from the revolutionary project of the total man, however, this outlook could never become anything more, at best, than an initiatory or hermetic doctrine.

So although Surrealism drew attention to each individual's potential for creativity in everyday life, it failed to spur the collec-

tive actualization of that creativity by means of a revolution made by all in the interests of all; instead, it invited the individual to lose his way twice over: to engage in a marginal activity which relied on Bolshevism to spark the revolutionary process, and to strive for a strictly cultural overthrow of culture. This de facto renunciation of the possibilities for subjective self-realization, even as these were invoked on the literary and pictorial levels, was accompanied by a call to sacrifice (from Breton on several occasions)—a call, in other words, to the castration which is the lynchpin of all hierarchical power. Those who had wanted to restore art to life thus ended up turning direct experience into just one more value on the art market. What prevented Surrealism from becoming a cultural cattle-trough, after the fashion of abstract art, existentialism, the *nouveau roman*, Pop Art, or happenings, was the fact that—unlike Aragon, Éluard and Dalí—Breton, Péret, Tanguy and Artaud did continue, confusedly and spontaneously, to reject anything in the movement that denied their subjectivity or ultimate uniqueness. In his "Preface for a Reprint of the Manifesto" (1929), Breton put into words what the best of the Surrealists almost certainly felt:

> If a system which I make my own, which I slowly adapt to myself, such as Surrealism, remains, and must always remain, substantial enough to overwhelm me, it will for all that never acquire the wherewithal to make of me what I wanted to be, as ready and willing as I might be for it to do so.

The choice of life, if not restricted to the role of nourishing literary or pictorial forms of expression, to the world of images, analogies, metaphors or trick words, is thus apt to lead to an incipient practice, to an embryonic science of man that is stripped of all positivism, as far removed as can be imagined from the specialized attitude of the "scientist", and inhabited by a desire to experiment in every direction, and to document all such experimentation to whatever extent might be required.

KNOWLEDGE OF THE HUMAN AND ITS
EXPERIMENTAL INVESTIGATION

Paul Nougé of the Belgian Surrealist group puts his finger on a very important concern of the movement when he writes:

> We must turn what can be ours to the very best account. Let man go where he has never gone, experience what he has never experienced, think what he has never thought, be what he has never been. But help is called for here: such departures, such a crisis, need to be precipitated, so with this in mind let us create disconcerting objects.

Leaving aside the faith thus placed in the earth-shattering power of such objects, whose transformation into commodities and conditioning mechanisms Surrealism failed to foresee, Nougé's proposition has the great merit that it prohibits from the outset any appeal to pure knowledge. Likewise, when the first number of *La Révolution Surréaliste* reiterated Aragon's formulation, in *Une Vague de rêves* [A Wave of Dreams], to the effect that "We have to arrive at a new declaration of the rights of man", the clear implication is that nothing that concerns thought, imagination, action, expression or desire must be deemed alien to the revolutionary project. The foundering of this project under the helmsmanship of Stalinism and its attendant leftisms was to reduce Surrealism to a mere generator of what might be called the special effects of the human. From this box of tricks, not altogether unlike a Renaissance "wonder-cabinet", albeit one richer in written testimonials than in actual phenomena, Breton and his companions contrived to produce a shimmering rhetoric, but despite all their efforts they were unable wholly to conceal the insurrectional purposes for which all these discoveries had originally been made.

"We need to form a physical idea of the revolution," said André Masson in *La Révolution Surréaliste*, Number 3, and here we have both a way of gauging the contribution of the human dimension and the key that in a revolutionary situation will make it possible to loot

(while at the same time enriching) the Surrealist storehouse of knowledge.

Before Breton located the moment of revolution in a mythical absolute where individual and collective history were supposed to come together, Guy Rosey, in *Violette Nozières* (1933), wrote the following lines, resounding like a last echo of Masson's watchword:

> *Here revealed at last by another inviolate self of hers*
> *is the personality*
> *unknown and poetic*
> *of Violette Nozières*
> *murderess as one might be*
> *a painter*

FREUD AND AUTOMATIC WRITING

A considerable portion of Surrealism's energy was applied to research into the limits of the possible, into extreme forms, varieties of expression, and the affirmation or destruction of the human phenomenon in its relationships with the world, as seen from the standpoint of a total liberation of the emotions. A multitude of characteristically Surrealist preoccupations arose from this attitude, among them the interest in spiritualism; the taste for Gothic novels; the experimentation with techniques of simulation and critical paranoia; the interest in childhood and in madness; the exploration of the world of dreams and of the unconscious or subconscious; the analytical approach to individual mythologies, as to the mythologies of allegedly primitive peoples (Michel Leiris, Breton, Artaud, Péret); the excursions into Celtic origins (Jean Markale and Lancelot Lengyel); the infatuation with alchemy and hermetic doctrines; and the construction of a new literary, artistic and philosophical pantheon which rescued many very great names from the silence, lies or discredit of official culture, among them Lautréamont, de Sade,

Fourier, Louis-Claude de Saint-Martin, Germain Nouveau, Oscar Panizza, Antoine Fabre d'Olivet, Alphonse Rabbe, Christian Dietrich Grabbe, Xavier Forneret, Alfred Jarry, Facteur Cheval, Arnold Böcklin, Monsu Desiderio, Albrecht Altdorfer, Nicolas Manuel Deutsch, Urs Graf, Jean Meslier, Pierre-François Lacenaire, Paracelsus, Basil Valentine, Achim von Arnim, Lewis Carroll, Edward Lear, Lichtenberg, Blake, Charles Robert Maturin, Monk Lewis, Adolf Wölfli, Jean-Pierre Brisset, Douanier Rousseau, Bettina, "the Portuguese Nun", Arthur Cravan, Jacques Vaché, Lotus de Païni, and many more.

The influence of Freud, whom Breton visited in 1921, was apparent from the very beginning. When the "Bureau de Recherches Surréalistes" opened at 15 rue de Grenelle, on 11 October 1924, its stated aim was to acquaint the general public with those psychoanalytical methods whereby anyone could attain better knowledge of their darker side and their hidden possibilities. Once rid of its dusty therapeutic pretentions, the art of psychoanalysis, along with the psychoanalysis of an art made by all, would be capable, according to the Surrealists, of laying the groundwork for a radically different form of social behaviour. The failure of this project even before it had been thoroughly clarified was to put the Surrealists at a distinct disadvantage in their attempt to make common cause with the Communist Party. The notion did not disappear entirely, however, for in 1945 we find Gherasim Luca, in his *L'Inventeur de l'amour* [The Inventor of Love], proposing a "limitless eroticization of the proletariat" as a general organizing tool and holding it as a self-evident truth that the dismantling of the initial Oedipal position must facilitate the qualitative transformation of love into a universal lever of revolution.

Freud also inspired the Surrealists in their hostility to the psychiatrists, to the inventors of the very notion of madness, to all who held sway over the world of children (those whom Jules Celma would later call "educastrators"). Breton evoked a childhood in which "everything, after all, ought to favour the effective and guaranteed possession of oneself", adding hopefully that "thanks to

Surrealism, it seems as if those conditions may be restored". "The liberation of children"—Roger-Gilbert Lecomte would later exclaim—"why, that would be even finer than opening the madhouses!" And here again is Breton, in *Nadja*: "But as I see it, all confinements are arbitrary. I still cannot see why a human being should be deprived of freedom." These are ideas that have since made headway: even if Celma was met with police repression, even if René Viénet was unable to obtain from the Sorbonne Assembly in May 1968 that a call be issued for the release of all those held in asylums, it is inconceivable that revolutionary movements of the future will fail to place such demands high on the agenda.

In the case of the Surrealists, it was the absence, again, of a practice concordant with the ideas held by the group that effectively downgraded the beginnings of a genuine psychoanalytically grounded social campaign—along the lines, perhaps, of that conducted by Wilhelm Reich, of whom incidentally the Surrealists knew nothing—to a mere technique of revelation and to mere cultural agitation.

This backtracking is already discernible in the *Manifesto* of 1924. In his "encyclopaedic" comment on Surrealism, Breton writes:

Surrealism is based on the belief in the superior reality of certain forms of previously neglected associations, in the omnipotence of dream, in the disinterested play of thought. It tends to ruin once and for all all other psychic mechanisms and to substitute itself for them in solving all the principal problems of life.

The adjacent "dictionary definition" runs as follows:

SURREALISM, n. Psychic automatism in its pure state, by which one proposes to express—verbally, by means of the written word, or in any other manner—the actual functioning of thought. Dictated by thought, in the absence of any control exercised by reason, exempt from any aesthetic or moral concern.

The importance the Surrealists attributed to automatic writing does little to offset the impression one often gets on reading even their finest texts that the movement gravely misjudged its own potential riches. By and large the practice of automatism, restricted to writing, failed to lead to any analysis of the ego, any uncovering of fantasies or strange drives, or any critique of language as a form of alienation. In short, it never got beyond Breton's original set of directions:

> After you have settled yourself in a place as favorable as possible to the concentration of your mind upon itself, have writing materials brought to you. Put yourself in as passive, or receptive, a state of mind as you can. Forget about your genius, your talents, and the talents of everyone else. Keep reminding yourself that literature is one of the saddest roads that leads to everything. Write quickly, without any preconceived subject, fast enough so that you will not remember what you're writing and be tempted to reread what you have written. The first sentence will come spontaneously, so compelling is the truth that with every passing second there is a sentence unknown to our consciousness which is only crying out to be heard. It is somewhat of a problem to form an opinion about the next sentence; it doubtless partakes both of our conscious activity and of the other, if one agrees that the fact of having written the first involves the minimum of perception. This should be of no importance to you, however; to a large extent, this is what is most interesting and intriguing about the Surrealist game. The fact still remains that punctuation no doubt resists the absolute continuity of the flow with which we are concerned, although it may seem as necessary as the arrangement of knots in a vibrating cord. Go on as long as you like. Put your trust in the inexhaustible nature of the murmur....

What was being proposed, in other words, was a means of renewing the artistic style, which had been in free fall since Apollinaire, and which Dada had turned into spare parts.

THE UNDERWORLD OF DREAMS AND PARESTHAESIAS

Dreams do indeed constitute that marvellous and unitary world whose immanence the Surrealists hymned. The Surrealists' theory of dreams, however, never progressed to a degree commensurate with the amount of attention they paid to the subject. Just as they left it to the "communists" to advance the cause of revolution, so likewise even their best contributions in this area (those of Breton, in *Communicating Vessels* and *Mad Love*, or those of Michel Leiris) were simply applications of Freud's arguments in *The Interpretation of Dreams*.

La Révolution Surréaliste was content merely to publish accounts of dreams, but it soon became apparent that oneiric inspiration also quickly turned into a literary technique. True, the occasional interpretation would endeavour to show how the beauty of an image can arise from a dream's short-circuiting of meaning, how the poetic spark may spring from a sudden condensation of different emotional significances that the dream contradictorily combines, how the illusion of premonition follows a particular dream pathway, and how, once the space-time of the dream has become identical with the space-time of myth, the signs of past, present and future may come to correspond to one another. Yet here too the absence of any implications of a practical kind took its toll, in this case a retreat into the ideology of "the great transparent ones" and hidden meanings. Confusedly aware, nonetheless, that mastery of dreams would imply mastery of life, and that meanwhile those who control survival, who run the government and the spectacle, need also to be the guardians of dreams, the Surrealists achieved their most concrete defence of the dream when they targeted the psychiatrists and alienists, psychoanalytical reformism, the technicians of social conditioning and all the watchdogs of the mental realm. The halfcocked nature of this campaign, however, meant that they never effectively demanded a society in which the fantasy world of dreams would have at its disposal, for the purpose of its material actualization, the entire technical armamentarium which under pre-

sent conditions serves only to destroy those prospects. The Surrealists were content to mine dreams in order to renew the images whose interplay so interested them; they failed to appreciate that this was another way for the dream to be co-opted by the dominant mechanisms of deception and fascination (as in the pillaging of dreams by the admen and the manufacturers of "silent majorities").

Much the same may be said in connection with forms of behaviour stigmatized as mad by the logic of profit, by the rationality of the commodity system: the contempt which the Surrealists heaped on torturers in white coats did not inoculate them against a temptation to co-opt attitudes usually treated clinically for purely artistic purposes. Thus, Dalí defined his "paranoiac-critical" technique as "a spontaneous method of irrational knowledge based on the interpretative-critical association of delusional phenomena", and he applied it notably to Violette Nozières, paronymic variations on whose name—"nazière", "Nazi", "Dinazo", "Nez"—inspired his drawing of a long-nosed figure the sexual symbolism of which evoked both the charm of the young woman and her father's attempt to rape her.

Similarly, an attempt was made to achieve a general rehabilitation of certain tendencies judged to be pathological. In 1928, to commemorate the fiftieth anniversary of the invention of hysteria, Number 11 of *La Révolution Surréaliste* published a beautiful series of photographs of female hysterics under the title "Passionate Attitudes, 1878". Breton and Aragon commented:

> Hysteria is a more or less irreducible mental state characterized by the overturning of the relations that obtain between the subject and a moral world to which, in a practical sense, and in the absence of any delusional system, he considers himself to belong. This mental state answers to the requirements of a reciprocal seduction which accounts for the hastily accepted miracles of medical suggestion (or counter-suggestion). Hysteria is not a pathological phenomenon, and it may justifiably be deemed, in every sense, a supreme form of expression.

In *The Immaculate Conception* (1930), Breton and Éluard composed texts based on the simulation of various types of mental illness.

Knowledge of the wild and repressed aspects of man also came from some who were less preoccupied with the reconstruction of art, among them Michel Leiris and other of Surrealism's fellow travellers, notably Georges Bataille and Maurice Heine.

Heine in particular (the first person clearly to hail the liberatory spirit of the pedagogical de Sade of *Philosophy in the Bedroom*) was a methodical explorer of the frontiers of human possibility. Better than anyone else, he grasped the hope that Surrealism held out for a real totality and a total freedom. His article in *Minotaure*, Number 8 (1936), "Regard sur l'enfer anthropoclasique" [A Look at Anthropoclastic Hell], in a sort of contrapuntal echo to the old Surrealist inquiry into suicide, sets forth an imaginary discussion between de Sade, Jack the Ripper, the Comte de Mesanges and Professor Brouardel on human beings as the objects of a long series of refined destructive measures and on the pleasure to be derived from their progressive and systematic degradation. Illustrated with photographs by the forensic surgeon Lacassagne from *Annales d'hygiène publique et de médecine légale* [Annals of Public Health and Legal Medicine], the text contrasts the transformation of man into an object, as promoted by a hierarchical social organization, with his destruction in the name of human passions. As the *negation* of slow reification, Heine proposes the project of the total man, a universe in which humanity would paradoxically be reborn from its paroxystic annihilation in the relationship between torturer and victim. The presumption is that this conscious nihilism, which is the nihilism of the great killers, will precipitate the transcendence of all the old world's negativity.

The same nihilistic perspective governs "Notes sur un classement psycho-biologique des paresthésies sexuelles" [Notes on the Psycho-Biological Classification of Sexual Paresthaesias], where Heine seeks to rid the scientific observation of man of the last vestiges of ethical and religious prejudice. He adopts the term "paresthaesia" in order to eliminate the false distinction between normal and abnormal and

apprehend direct experience as a unity despite all its contradictions. Heine's writings—among which "Confessions et observations psycho-sexuelles" also deserves mention—opened a line of inquiry which Bataille was to pursue but on which most Surrealists quickly turned their backs.

Dalí, however, was well aware of the potential for provocation in any attribution of aesthetic value to acts condemned by puritanical laws. For example, in the second issue of *Le Surréalisme au Service de la Révolution*, he elected to celebrate a non-destructive and perfectly banal paresthaesia, namely exhibitionism:

> Last May, between Cambronne and Glacière on the métro, a man about thirty, who was seated opposite a very beautiful young girl, cleverly parted the pages of a magazine that he was affecting to read, so arranging things that his sex, fully and magnificently erect, was exposed to her view, and to her view only. No sooner had another passenger, an idiot, become aware of this act of exhibitionism, which had plunged the girl into an enormous but delightful state of embarassment, though without eliciting the slightest protest from her, than the mass of travellers fell upon the exhibitionist, hitting him and throwing him out of the carriage. We must cry out in utmost indignation and express our utter contempt for such an abominable way of treating one of the purest and most disinterested acts of which any man is capable in this effete and morally degenerate age.

However sympathetic one might find this attitude, it was certainly never extended to a general defence of paresthaesias; at best it was subsumed by black humour, at worst incorporated into the stock of images which Dalí used, only slightly in advance of sexually orientated advertising, to test the shock effect of representations of erection, masturbation or defecation.

Similar themes inspired Éluard to produce genuinely charming verse:

In a corner agile incest
Circles around the virginity of a sweet little dress

But even had aesthetic co-optation not dominated the Surrealists' concerns, their lack of the sense of totality that moved Maurice Heine and no doubt also Georges Bataille would have sufficed to reduce any fresh ethical demands on their part—any invocation of a right to free love, incest, exhibitionism or homosexuality—to the role of a mere stimulant to the regeneration of the old order of things. André Thirion had clearly grasped this paradoxical truth when, in *Le Grand Ordinaire*, he offered a jocular demonstration of how incest can serve to buttress the stability of the family:

"Our miseries are due to the fact that we have forgotten the old ways," declared our friend Moscheles in grave tones as he was getting his circumcised member sucked by his youngest daughter Sarah, who was barely thirteen. "Modern life has devalued the pure joys of home and hearth, and every day the practice of sports takes children a little further away from their parents, and exposes them to a thousand temptations. (No, Sarah! Work on the head—how many times do I have to tell you! And for goodness sake don't be afraid to use your tongue as much as you can!) One only needs think of the extreme freedom of manners, in fact the sheer licence, that permits the horrifying way couples dress at balls, in the street or in public parks. As for the latest, camping holidays, they encourage a quite indecent promis-cuity, indeed I can't see how camping differs from vagrancy pure and simple. And have you ever read the columns in some of the women's weeklies? They actually recommend love affairs! Adultery is supposed to be a good thing! Sarah, come on, girl! Don't go to sleep on the job!"

CHAPTER 3

TRANSFORMING THE WORLD

REVOLUTIONARY IDEOLOGY

The failure of the Barrès trial, as of all other efforts to equip Dada with a social and political consciousness, led to the adoption of Marxism, as revised and corrected by Lenin, and to the abandonment of Dada's two great enterprises—the quest for total negation and the project of a collective poetry. The latter, had it succeeded, would have evolved into a critical theory in search of its practical self-realization through the overthrow of all the conditions presently imposed on the world and on everyday life. As we have noted, the Surrealist group at its very inception—unsurprisingly, in view of the artistic preoccupations of its founders—already bore the traces of this twofold renunciation. This was the root, furthermore, of a guilty conscience whose persistence throughout the entire history of the movement manifested itself as a fundamental and unshakeable despair and a continual hankering, in consequence, for self-justifications and exorcisms. This despair of the ego, which in time developed existential overtones, was simultaneously contained and combated by the Surrealists' leftism. Until their break with the Communist Party, they accepted a functional role in the political realm; thereafter that role became a caricature, and remained so until the advent of a completely new official leftism in 1968.

The words that occur most frequently in Surrealist ideology are "revolution" and "love", and it must be said that, no matter how confusedly and abstractly they may be used, certainly no infamy attaches to these words—no bloodstains intellectual or otherwise. There is indeed something very touching about Péret and Breton's tireless efforts to keep their ideology pure—or, as Breton so loved to say, "immaculate"—especially since, *qua* ideology, it was impure by definition. Frequently this mix of rigour and naïvety, produced in a context of pragmatism or tactical manoeuvring, would acquire the poetic aspect of a childish virtue ("childish" being understood in the positive sense that it had for Fourier). Here, for instance, is Breton speaking at the Barcelona Ateneo on 17 November 1922:

There is only one thing that can get us out, if only for a moment, of the horrible cage in which we are trapped. That thing is revolution—any revolution, no matter how bloody—and to this day I call for it with all my might. I am sorry if Dada did not turn out to be that revolution, but you have to understand that nothing else much matters to me.

Breton made himself even clearer in the collective manifesto "La Révolution d'abord et toujours" [Revolution First and Forever], reprinted in Number 4 of La Révolution Surréaliste (15 October 1925), asserting that "the idea of Revolution is the safeguard of everything that is best and most effective in the individual". We may reasonably take this libertarian sentiment, to which Breton and Péret would always remain loyal (even if Breton occasionally failed to live up to it in practice), as embodying precisely that element of "innocence" which kept Surrealism at arm's length from Bolshevism and ultimately meant that the movement's heyday would be remembered for its attempt (quite rare in history) to create an innocent ideology.

This attitude also accounts for the charming lyricism which compensated for Surrealism's lack of analysis: "I move through a landscape," wrote René Char in Le Surréalisme au Service de la Révolution, Number 3, "where Revolution and Love together illuminate amazing perspectives and deliver shattering disquisitions."

The very confusion that enveloped the notion of revolution allowed it to encompass the daydreams of subjectivity, the human passions, the will to live, the violence of individual demands—indeed everything that tended to resist being reduced and manipulated by bureaucratic revolutions. But this "everything", sad to say, was just what Surrealism could apprehend only in bits and pieces, in fragments which in their fragmentariness were inevitably inconsequential.

To begin with, sincerity and anger still took precedence over concern with the poetic image. Thus Desnos's "La Révolution, c'est-à-dire la Terreur" [Revolution, That Is To Say, Terror], in La Révolution Surréaliste, Number 3, was able to recapture the finest libertarian cadences of an earlier day:

But what a relief it would be to witness a methodical purge from the population of all founders of families, all doers of good works (charity is a mark of degeneracy), all priests and pastors (let us not forget that crew), all soldiery, all those people who, if they find a wallet in the street, will immediately return it to its rightful owner, all fathers à la Corneille, all mothers of exemplarily large families, all depositors in savings banks (worse than the capitalists), the police as a body, men and women of letters, inventors of serums against epidemics, "benefactors of humanity", dispensers and recipients of compassion—if only all this rabble would just disappear! The greatest Revolutions are born of strict adherence to a single principle; the motive for the Revolution that is coming will be the principle of absolute freedom.

In this admirable last sentence Desnos unequivocally defends a genuine collective poetry against the appropriation of the Revolution of 1917 by the Bolsheviks and their State. As much cannot be said of Éluard's ambiguous comments in *La Révolution Surréaliste*, Number 4 (5 July 1925), apropos of a public declaration by the Philosophies group:

The optimism of the *Clarté* people shone in all its glory beneath the hammer-and-sickle sun of a mediocre régime founded, just like the capitalist régime, on the facile and repugnant reign of work. Truth to tell, it barely matters to those who are born revolutionaries that the inequality of classes is unjust.

That Éluard could thus quite rightly condemn the reign of work, and then in the very next breath, with unparalleled stupidity, disparage the class struggle, gives us some clue as to how it was that the Surrealists (always thought of as clowns by even the most primary and least cultivated of Marxists) were able for a time to accept the role of faithful disciples, first to the Communist Party and later to Trotsky.

Three months later, however, Éluard had clearly made progress, for he signed the joint Surrealist-*Clarté* manifesto *La Révolution d'abord et toujours*, which included the pronouncement: "We are not Utopians: we conceive of the coming Revolution as strictly social in character."

Unfortunately, the social character in question was that of social oppression, as per the Bolshevik model. Breton, in *Le Surréalisme au Service de la Révolution*, Number 2, concluded a discussion of "The Relationship between Brain Work and Capital" with a proto-Maoist exhortation:

> there is no need to give house-room to specifically intellec-
> tual pleadings which, inasmuch as they have any justifica-
> tion at all, have no business manifesting themselves in the
> form of vain corporatist campaigns but ought far rather to
> persuade those who suffer in this way in the present order
> of things to serve the proletariat's admirable cause unre-
> servedly, and treat that cause just as if it were their own.

The notion of intellectuals serving the people (a watered-down version of Blanqui's theory) was one of the most laughable ideas that the Surrealists ever espoused. Dada had pointed out the congenital impotence of intellectuals as such, condemned as they were to reign over a dead planet and issue decrees with no force in law until such time as the State's real laws assigned these ghosts a *role* in the general system of appearances and lies. A world away from Dada's radical-ism, Surrealism dreamed of a cultural revolution (much like one that would come later) which the Communist Party could turn on and off like a tap. The scandal at the Closerie des Lilas in July 1925 aptly foreshadowed the Red Guards' "storm in a teacup of piss".

Surrealism's leftist critique was not always without merit: an exhibition called "The Truth About the Colonies" (September 1931) was a case in point. But if the Surrealists occasionally became the critical consciousness of the Communist Party, the Communists never gave a hoot for these butterflies and their fascination with that great proletariat-crushing machine, the Party bureaucracy.

In *Légitime défense* [Self-Defence, 1926], Breton writes: "Upon reflection, I do not know why I should abstain any longer from saying that *L'Humanité*—childish, declamatory, unnecessarily *cretinising*—is an unreadable newspaper, utterly unworthy of the role of proletarian education it claims to assume." "I cannot understand," he goes on, "that on the road of revolt there should be a right and a left." "I say that the revolutionary flame burns where it lists, and that it is not up to a small band of men, *in the period of transition we are living through*, to decree that it can burn only here or there." Conspicuously absent from all this discussion is the proletariat, and René Daumal is right to direct his irony at the supposed Marxists of the Party and the left-wing sects, whose "total failure to comprehend the dialectic makes them infinitely more ignorant than absolutely any revolutionary worker, for whom the very least that may be said is that he *lives* the dialectic".

Needless to say, merely by imagining that the masses might be reached via the Communist Party, Surrealism automatically prevented itself—quite aside from the grotesque nature of such an illusion—from speaking the language of revolution or from ever developing a radical discourse. The idea of a poetry made by all, had it ever been properly analysed and carried to its logical conclusion, would have been found to embody the revolutionary theory of generalized self-management—that "invisible ray", to borrow Breton's description of the surreal, "which will make it possible for us one day to rout our adversaries".

As I have tried to show above, Surrealism did have a theory, albeit a latent, fragmentary one, quickly swallowed up by ideology. It was concerned with privileged moments of life and the quest for such moments, with love and its subversive potential in everyday life, with the analysis of the quotidian and its alienations. It never rose to the level of a critique of Bolshevism, even though Breton was capable, belatedly, of offering an implicit correction to his appalling juxtaposition, in a sentence such as the following, of the author of *Poésies* and the author of *What Is To Be Done?*: "Surrealism is part of a

vast undertaking, of that reconstruction of the universe to which both Lautréamont and Lenin committed themselves utterly."

When polemics broke out between the Surrealists and their old friend Pierre Naville, the opposition between culture and social organization was addressed by neither side. "Quarrels of the intellect", wrote Naville in *La Révolution et les intellectuels* (1926), "are absolutely vain in face of this one unified condition [wage-labour]." A few pages earlier, however, he had already exposed the limits of his own intellect and of his thesis, once again bringing up a dilemma that had haunted the Surrealists ever since their failure to understand Dada: "Do the Surrealists believe in a liberation of the mind prior to the abolition of bourgeois conditions of material life, or do they think that a revolutionary mind can only come into existence in the wake of a successsfully completed revolution?"

Everyone stuck to their own position, and no critique of social separations was ever broached by any of the parties. Thus Breton held that revolution must concern the facts *and* the mind, Naville that it must affect the facts before it can affect the mind, while Artaud held out for the primacy of the mind in the genesis of revolution.

It was not long before the Stalinist virus made its appearance. No one blinked when Georges Sadoul, as part of a denunciation of the French police in the December 1929 issue of *La Révolution Surréaliste*, stated flatly that he would like "to take this opportunity to hail the GPU, a counter-police in the service of the proletariat, every bit as necessary to the Russian Revolution as the Red Army". And barely a murmur was heard when Aragon, in "Red Front" (1931), famously cried "Long live the GPU, dialectical figure of heroism". Only Roland de Renéville, then close to the Grand Jeu group, ventured to point out that Aragon's poem "ends with a hymn to the GPU which, seen from the prophetic standpoint of the mind, becomes simply a hymn to the police".

Later, after the break with the Stalinists, Breton turned more unequivocally towards Trotsky. With Trotsky he collaborated on the manifesto "For an Independent Revolutionary Art" (1938). (At

Trotsky's request, Diego Rivera co-signed with Breton in his stead.) Before long, however, Breton was admitting his astonishment that Trotsky could invoke the old Jesuit precept that "the end justifies the means", and he called immediately for "a thoroughgoing critique of certain aspects of the thought of Lenin and even of Marx". He himself never followed up on this.

After the Second World War the political action of Surrealism was intermittent and scattershot. The discovery of Fourier might perhaps have underpinned an overall recasting of the movement, but Breton would always prefer Fourier the visionary, Fourier the poet of analogy, to Fourier the theorist of a radically new society.

Péret and Breton's last successors took Cuba instead of the USSR as the object of their enthusiasm. Echoing the sometime sinister good faith of a Sadoul, Jean Schuster would write, in *Batailles pour le surréalisme:*

> What could possibly be more legitimate than that a revolutionary society, in the process of constructing socialism, should find itself obliged, as Cuba does today, to require a surplus of labour from its members, thus ensuring that work be as fairly shared and equally remunerated as possible?

AN INFORMAL ORGANIZATION

Spurred by its own internationalism and aided by the crisis conditions in all industrialized countries, Surrealism swarmed far and wide. Groups modelled on the French one sprang up in Rumania, Yugoslavia, Czechoslovakia, Scandinavia, Belgium, Italy, South America, the Canary Islands, Mexico, Japan, Haiti. Direct contacts generally accompanied the establishment of relations between groups. The French group set the tone—which meant, most often, that Breton set the tone.

The basis of recruitment, indeed the basis of the group, had much to do, no doubt, with Breton's claim in *Les Pas perdus* that "One publishes to find people, and for no other reason"—an ambiguous statement indeed if one considers how generous, yet at the same time how authoritarian, the author of *Nadja* could be. Breton was a brilliant thinker, but he was less radical than Péret. The ardour he brought to friendships whether transient or enduring was such as to plunge him now into blind faith, now into wild rage. Even though he was as fond of imposing his views as others were to oblige him in this, the fact remains that the Surrealist group never developed any but the most fluid of hierarchies. Deeper probing would doubtless assign Benjamin Péret a more important role, for, so far from being the second-in-command, the faithful lieutenant that an obtuse view of things has portrayed, Péret was in fact the most independent and libertarian member of the movement. It was thanks to him, in all likelihood, that nearly all the group's decisions were arrived at in a largely democratic way.

Breton was the centre, certainly, but this also made him into a target, and those whom he allowed himself to treat as friends, just as much as those who allowed themselves to put up with him as a friend, rarely lost an opportunity to mock his seriousness, his lack of humour, his tantrums, his tendency to choose people's apéritifs for them. The most serious charges, no doubt, were made by Desnos:

74

André Breton detests Éluard and his poetry. I have seen Breton throw Éluard's books into the fire. Admittedly, it was on a day when the author of *L'Amour, La Poésie* had refused to loan him ten thousand francs—that is, unless Breton was prepared to sign a bill of exchange. So why does Breton continue to sing the praises of Éluard and his work? Because Paul Éluard, as Communist as he claims to be, is a property speculator, and the money he gets from selling swampland lots to workers is used for buying the pictures and African art in which the pair of them deal.

André Breton detests Aragon, and never tires of recounting his infamies. Why then does he show him any consideration? Because he is afraid of him, and he knows that a break with Aragon would spell disaster for himself.

André Breton once broke off with Tristan Tzara for the very precise reason that when we attended Tzara's "Evening of the Bearded Heart", the Dada-in-chief had us arrested. Breton knows this very well. He saw and heard Tzara denouncing us to the policemen just as clearly as I did. Why is he now reconciled with Tzara? Because Tristan Tzara buys Negro fetish objects and paintings and André Breton sells them.

In an article of his on painting, André Breton takes Joan Miró to task for having made a little money along the way. But it was he, Breton, who, having bought the painting "Ploughed Land" for five hunded francs, turned around and sold it for six or eight thousand. So Miró may have come across a little money along the way, but it was Breton who stuffed his pockets with it.

As serious as a pope, as dignified as a magus, as pure as Eliakim, André Breton is the author of *Surrealism and Painting*. It is a curious fact, however, that the only painters who find unconditional favour in his eyes are those with whom he can do business.

What Desnos rightly condemns here, albeit after the fact, is indicative at the very least of a malaise in the Surrealists' interpersonal relationships. What is this concern with the art market, repressed

or concealed behind the firmament of ideas, if not history's knowing wink in the direction of those who have been paying it no heed? The basic fraud perpetrated by Surrealism thus emerges quite clearly on the factual plane: the *ideology* of an art that serves life cannot long prevail over the *reality* of art and survival being pressed into the service of a spectacular society founded on the commodity system.

In the 19 October 1924 issue of his review *391*, Picabia described Surrealism as "nothing but Dada in the travestied form of an advertising balloon for Breton and Co." Surrealism indeed gave the appearance of being above all a scheme whereby Breton sought to establish an objective basis for his subjective choices, tastes or passions. That he should also make business deals under cover of the movement was in the order of things—part of the shameful aspect of all ideology. But simply to denounce Breton was not enough: what needed closer scrutiny was Surrealism's unhealthy and suspect defence of the work of art (poetry, painting, object or image).

As soon as art was reinvested with value, the natural *arrivisme* of the artist, complete with the desire to make a name and promote an *oeuvre*, was bound to follow. This tendency, though officially condemned by Surrealism, existed within the group itself. Breton may have written, in *Pleine marge* [Wide Margin] (1940), that "I am not for adepts"; the fact remains that, except for Artaud and Péret, he was never to have anything but adepts, and indeed he took very good care of their proper initiation, so as never to be surrounded by anything but discreet approbation.

It is in the shadow of this particularly distressing kind of behaviour that the question of breaks and expulsions has to be considered. "Without being obsessed by personal rancour and refusing to derive our private anguish on every occasion from the social conditions imposed upon us, we are obliged to turn around at every moment, and to hate"—thus Breton in *Légitime défense*. There is no denying that expulsions and the breaking off of relations are the only arms available to an intellectual group. The problem in the case of the Surrealists was that the struggle against compromise was waged from

the standpoint of an ideology, that is to say, from the standpoint of an initial compromise struck with the ruling order.

The Surrealist group expelled quite a few notorious idiots who had been admitted in the first place out of misplaced indulgence. Joseph Delteil, author of a life of Joan of Arc, and Maxime Alexandre, who would later convert to Catholicism under the auspices of Paul Claudel, are cases in point, and there were others. This by no means prevented the Surrealists from making common cause with such mediocrities as Camus and Ionesco, or, especially in the post-war period, from keeping company with some truly pathetic characters.

There were expulsions, too, that were utterly well founded: expulsions for political reasons, or on the grounds of irreconcilable differences (as with Artaud), or for attitudes that were repugnant (Aragon, Sadoul, Éluard, Dalí). And finally there were expulsions, at once the most significant and the most questionable ones—and the most indicative of the movement's malaise and its need to exorcise it—of artists or writers seduced by the appeal of money and acclaim.

Surrealism demanded of its exponents that they not participate in the spectacular and commodity-driven system of which the movement itself partook willy-nilly. When Breton threw Philippe Soupault and Robert Desnos out, accusing them of literary coquetry, he would have done well to heed the already resonant cautionary words of René Daumal: "Beware, André Breton, lest you figure in future textbooks of literary history; remember that the only distinction we ever aspired to was to go down in the annals of cataclysms."

The fact is that Surrealism accepted compromise—up to a point. It was acceptable to deal in works of art, or to achieve distinction by producing such works, but only to a certain degree. And in Breton's eyes the gauging of that degree was his prerogative. "It has often struck me", noted Victor Crastre in his *Le Drame du surréalisme*, "that active spirits were rare in the group. All decisions were taken by a small directorate comprised of Breton, Aragon, Éluard, Desnos, Péret and Leiris, then accepted without further discussion. Critical reac-

tions were voiced as infrequently among the Surrealists as in any highly organized party."

How could a group with such a passive attitude towards real struggles in the outside world condemn passivity in its own members? How could a group accepting of hierarchies oppose ambition and opportunism? And how could a group whose instincts were essentially cultural be expected to withstand the co-optive mechanisms of a culture that was inexorably falling under the sway of the economy and its representations?

CHAPTER 4

PROMOTING THE IMAGE AS OBJECT

LANGUAGE AND ITS SUBVERSION

The adventure of the arts (painting, sculpture, poetry, literature, music) passes in its decline through three essential phases: a phase of *self-liquidation* (Malevich's "white square", Mutt/Duchamp's urinal rebaptized "Fountain", Dadaist word-collages, *Finnegans Wake*, certain compositions by Varèse); a phase of *self-parody* (Satie, Picabia, Duchamp); and a phase of *self-transcendence*, exemplified in the directly lived poetry of revolutionary moments, in theory as it takes hold of the masses, or in this notice posted on Saragossa Cathedral by Ascaso and Durruti, and followed up by the action announced: "Having learnt that injustice reigns in Saragossa, Ascaso and Durruti have come here to shoot the Archbishop."

Surrealism partook of each of these three tendencies but gave itself over to none of them; on the contrary, it deformed them to the benefit of the same separate art and separate thought whose demise they were intended to embody. Hence the real conflict was transmuted into ideology, into a system of ideas which was cut off from reality, simultaneously concealing and distorting it. On the moral plane this process created a confrontation between an ethic of purity and a surrender to compromise; on the aesthetic plane, submission to the ruling language of words, signs or art stood opposed to the refusal of that language, its redirection, subversion, and replacement by the magic of images and objects drawn from the adventure of everyday life.

True to Dada, Francis Picabia passed definitive judgement on art when he described it as "a pharmaceutical product for imbeciles". And here is Artaud, as late as 1927, in *Le Pèse-nerf* [The Nervometer]: "All writing is pig-swill. People who come down from their clouds to try and say anything at all about what is going on in their heads are pigs. All literati are pigs, especially those of the present time."

But it was not in the same spirit as Picabia or Artaud that Surrealism rejected art and writing. Its rejection concerned the writing only of an André Gide, an Anatole France or a Paul Claudel, the

art only of the Cubists, the Abstractionists or the Salon painters. Even in 1952, speaking on Gide, Breton still felt compelled to assail what he called a "marvellous specimen of a species that we Surrealists have ever wished extinct, that of the professional *littérateur*, the individual perpetually gnawed by the need to write, to publish, to be read, translated, commented upon—the type of person who is sure that he will "hook" us, and that he will "hook" posterity too, through the sheer quantity of his production, just so long as this is not attained at the expense of style."

Unfortunately the distinction implied is a completely false one, and indeed allows the very worst varieties of literature to escape rebuke. For proof of this, were proof needed, one has only to re-read all the literary testimonials, all the effusive prefaces, all the backscratching puffery that the Surrealists allowed themselves to produce as favours to friends; alternatively, one has only to contemplate the unspeakable exercises in style published in the Surrealist periodicals of the postwar period.

At the same time, however, their creative experimentation brought the Surrealists face to face with the redoubtable language which is not merely the idiom of Gidean literature but, far more broadly, the dominant mode of all communication, all expresssion. They were thus very soon dealing with two correlations: that between this dominant language and the forces of repression and deception, and that between living speech and revolt. In *Légitime défense* Breton ridiculed Henri Barbusse, the Party intellectual, who was calling for artistic renewal, in the following terms: "What does this artistic renaissance matter to us? Long live the social revolution, and it alone! We have a serious account to settle with the mind, we are too uncomfortable in our thought...."

Péret also took aim at the alienating character of detached thought and of the prevailing use of language: "There are certain sentences that completely prevent me from making love." Implied here, of course, is the existence of a language (understood broadly enough to include attitudes, songs, gestures, speech, and so on)

which on the contrary encourages us to make love, and indeed to make revolution. Surrealism, though it may not have overlooked such a language completely, cannot be said to have come very close to it. The movement's confinement within culture limited it to developing and experimenting with a mere shadow of the revolution of language, and this under strictly isolated conditions: the Surrealists championed an emancipation of words and images that mistook a certain autonomy for real freedom and chance abstract associations for real gauntlets thrown down to the old world.

Still, the more radical felt the temptation to identify poetry, as the main counter-language, with revolutionary theory, which detaches itself from the real struggles of the proletariat, then rejoins them in the shape of a radicalizing practice. Thus André Thirion and Pierre Yoyotte did produce a number of fine Marxist analyses, even if critical thought was not significantly advanced thereby. The notion that the true language of poetry governs action and contributes to its fulfilment must in fact be sought elsewhere. Certainly such a language has nothing in common with the verbiage and the Stalinizing gullibility of Aragon's "Red Front". Nor does it jibe with insults and sarcasm (as in "Jean Cassou, Dog-Savant; Marcel Arland, the Town Sewer; Albert Thibaudet, Friend to Tooth Decay; Maurice Maeterlinck, Featherless Bird; Paul Valéry, Natural-Born Clown; Cocteau the Stinking Beast", etc., etc.), unless such insults follow or announce events calling for an immediate scandalous or violent response. A case in point is the pamphlet *A Corpse*, published on the occasion of the death of Anatole France (1924). In sharp contrast to the ordinary use of the literary insult, *A Corpse* broke with the convention according to which no ill should be spoken of the dead, and effectively rehabilitated desecration; words here were not separate from action, indeed their role was to occasion action, and to establish a precedent.

Similarly, a genuinely poetic function is met by the following lines, published upon the death of Joffre, but three years before that of Poincaré:

Marshal Joffre
Marshal Foch
Georges Clemenceau
and President Poincaré
> *will ever endure in our memory*

Péret and Éluard strove to bridge the gap between poetry and the act envisaged, but it has to be said that their call to murder in the following passage lies open to the charge which revolutionary tactics must perforce level at any gratuitous terrorism:

> In France our own shithouse Mussolini has once more crawled out of the sewer. Poincaré presides as the "average Frenchman" over banal events and rotting straw men. How much longer can he stay the obviously willing hand of the assassin?

As a rule it was Péret who unerringly found the sensual language of the true cry of rage and execration. His *Je ne mange pas de ce pain-là* puts one in mind of the chants intoned by ancient Welsh bards, which according to Julius Caesar struck such terror into enemies that they had been known to fall dead on the spot. Rarely has the power of contempt, in the struggle against the oppressiveness and stupidity of authority, attained such an intensity of raw eloquence. The heroism of the patriot will remain a dead letter until we forget the words:

> *Rot Condamine de la Tour*
> *Rot you spineless shit.*

And great leaders will have to ponder their weight in history so long as little children continue to recite Péret's ditty about "Tiger" Clemenceau:

> *He has croaked*
> *Eat him maggots "to the last ditch"*
> *Devour this corpse*
> *And let his bones whistle up the revolution.*

When it came to the language of practice, however, Péret dealt merely with its most directly emotional and immediate dimension. Like all the Surrealists, whose real practice was more artistic than revolutionary, he never tested radical theory, reducing it instead to a challenge to the ruling ideological language that was itself couched in ideological terms.

Breton is on the way to a serious analysis of the language of the dominant ideology in "Introduction to the Discourse on the Paucity of Reality", when he notes that "words tend to group themselves according to specific affinities whose general result is to recreate the same old world over and over again". But he fails to grasp that such a language is simply the most highly sophisticated and persuasive form of the ideological system which power (that of the ruling class or caste) uses to assert itself. Thus when he goes on, apropos of words, "It is enough that we direct our criticism at the laws that govern their assembly", he refuses to understand that only the language of total subversion—only radical theory or practical poetry—can successfully destroy both the dominant language and the old world. By contrast, to assert that "words play, words make love" is to claim to be combating the language of power while actually renewing and modernizing that language and giving it a fresh appearance of life.

The most lucid tendencies within Surrealist ideology were forever seeking to retrieve the repressed radical moment of Dada's final period, and indeed several such tendencies (paralleling differing attitudes towards art) are clearly distinguishable, including self-parody, the hope for transcendence, the will to destruction, and the literary option.

The subversive nature of Dadaism's word-collages was inherited by the Surrealists in its playful aspect only. It is true that Marcel Duchamp's dalliance with infectious phonetic puns and wordplay retained a certain demystifying power:

Le système métrite par un temps blénorrhagieux
The metritic system [not the metric system] during blenorrhagic
 [as opposed to *orageux*, or stormy] weather

Du dos de la cuiller au cul de la dourairière
From the back of the spoon to the arse of the dowager

La bagarre d'Austerlitz
The dust-up [not the *Bataille*, and not the *Gare*] of Austerlitz

Rrose Sélavy trouve qu'un insecticide doit coucher avec sa mère avant de la tuer
Rrose Sélavy feels that an insecticide ought to sleep with its
 mother before killing her

Les punaises sont de rigueur
Fleas are required

 Michel Leiris uses a similar method to illuminate the mysterious
analogies thrown up by the reveries of subjectivity, by the secret
agencies of the mind, as witness these two plays on words from his
"Glossaire: j'y serre mes gloses" [Glossary: Where I Keep My Glosses]:

Épaves: elles pavent la mer
Wrecks: they pave the sea

Fantôme: enfanté par les heaumes
Ghost: something born of helmets

The second "definition" here contains a covert reference to the fan-
tastic scene in Horace Walpole's *The Castle of Otranto* where a gigan-
tic helmet appears in the castle yard.

 Whereas Leiris sought to uncover a language whose fluidity
allowed it to express the vicissitudes of subjectivity, whose reso-
nances referred us to the inner life of the individual (several of
Leiris's books analyse language as the receptacle of a personal
mythology), Breton for his part fostered belief in an objective
counter-language in which the connections between words could
escape the control of the dominant language and its rationality. The

Surrealists clearly believed that the reigning *language-in-itself* could be successfully contested by means of an abstract form of *language-for-itself*. That there is such a thing as language-for-itself is amply demonstrated by the language of revolutionary moments. The signs of that language are many and various, and they all tend towards unification in a general insurrectional movement, in a global transcendence. Leiris showed this tendency at work in the individual; the art of children and the art of the mad exemplified it in a partial way. But it was only in such fragmented or epiphenomenal manifestations, unfortunately, that language-for-itself was perceived by Surrealism.

The Surrealists conceived of a counter-language—which to begin with never answered to anything beyond a need to get out of the rut of traditional poetry, to write a different kind of poetry—as an immediate given. This entirely literary requirement gave rise to research of two kinds: research into the autonomy of the relationships between words and research into the psychoanalytical unity of those relationships.

Lautréamont's evocation of "the chance encounter of a sewing machine and an umbrella on a dissecting table" was the starting-point for the Surrealists' laboratory experiments with language. The game of Exquisite Corpse was based above all on the principle of objective chance. It is defined in Breton and Éluard's *Dictionnaire abrégé du surréalisme* [Abridged Dictionary of Surrealism, 1938] as follows:

> A folded-paper game in which sentences or pictures are created by several people, none of whom can tell what the contribution of any preceding player may have been. The classic example, which supplied the name of the game, is the first sentence ever obtained in this way: "The exquisite corpse shall drink the new wine."

Breton proceeded, in *Communicating Vessels*, to try and identify an internal logic common to all sentences thus generated. The model, once again, was Lautréamont's phrase:

Anyone who contemplates the extraordinary power that can be exerted upon the reader's mind by Lautréamont's celebrated formulation, "as beautiful...as the chance encounter of a sewing machine and an umbrella on a dissecting table", and who is willing to consult a key to the simplest of sexual symbols, must quickly concede that this power derives from the fact that the umbrella here can stand only for a man, the sewing machine only for a woman (this would be true, moreover, for almost all machines, a reinforcing factor in this case being that sewing machines, as is well known, are often put to onanistic uses by women), and the dissecting table only for a bed—which is itself the common measure between life and death.

When one compares Breton's observations with Leiris's approach, the difference is quite striking. Leiris sought to circumscribe the language of desire, whereas Breton wanted to establish and explicate a new kind of beauty—to promote, in short, a more human aesthetic. Breton had one foot in literature and the other in reality as directly experienced. His entire work bears the traces of his resulting discomfort, even though he had the wit to transform this hobbled state into a thought of great elegance.

To the political right of Breton, the literary option carried the day. In the case of Éluard, for instance, that choice was unmistakable: "Lovers are not necessarily the authors of the most beautiful love poems, and even when they are they do not make their love responsible for it." Here direct experience is deemed less important than its representation, than its image—a perfect epitome of the alienation of life by culture.

To Breton's left, meanwhile—if we except Leiris, whose research, though of genuine interest, did not lead to any social practice, and so degenerated into positivism—the memory of a possible transcendence shaped two contrasting trajectories, that of Péret and that of Artaud.

Apart from that portion of his work in which he sought to push poetic invective as far as it would go (notably *Je ne mange pas de ce pain-*

là), Benjamin Péret devoted his energies to the construction of a kind of linguistic Château de Silling whereby, much as de Sade aspired to produce an exhaustive catalogue of sexual fantasies, he strove to inventory every conceivable metaphorical combination. Péret was undoubtedly the only person ever to create a counter-linguistic world, a world directly accessible to all children and impenitent dreamers, and a world which cries out for social revolution as the only natural means of exposing its profound banality to all:

> It was a great rage—the great rage of a faded flower tossed upon a church roof—that now shook Nestor. "Just think," America had told him, "I am Wurtemberg." And when Nestor had replied that New York was not in Wurtemberg, America had retorted angrily that New York had indeed been the capital of Wurtemberg ever since the sea-legged squid had dragged into its pincers, known as tentacles, a child hanging from a branch on Fourteenth Avenue like a cherry from an olive tree. Nestor, sure that he was in the right, lit up a pipe that he had previously loaded with pearl-oyster shells, which allowed him to say with pride, "I smoke only pearls." Lighting a pipe is not enough, though—you also have to smoke it. Nestor soon found out that this was an impossibility. His pipe was smoking but he was not.

> (from *La Brebis galante* [The Amorous Ewe])

The discovery of automatic writing compensated for the lack of consistency in Dada's negativity, but it meant that the aspiration to a language of the totality was now abandoned in favour of the search for a merely linguistic totality. Automatic writing was Artaud's starting-point too, but he took the opposite tack to Péret, directing his attention to the inner life of the mind, to the drama of alienated consciousness. Though just as far removed as the other Surrealists from the historical dimension of the antagonism between spontaneous verbal associations and language-in-itself, Artaud did succeed in isolating this contradiction and treating it as an ontological malady, as the curse of being (whence his continual casting about for exorcisms

of one kind or another). A manuscript of his pinpoints the origin of that oscillation within which he situated himself, somewhere between the disaster of writing on the one hand and spiritual and physical disaster on the other:

In the realm of the determinate, only those phrases which flow directly from the unconscious can ever reach full flower. But if perchance my conscious mind awakes, either because [*lacuna in manuscript*], or because of an external event, then I become aware of the obstacles that stand in the way of the fulfilment of my thought. Such obstacles are always of the same order: ideas are stripped of their meaning, of their neuronal or affective content, at whatever point in their formation or materialization one apprehends them, at whatever point one becomes aware of their degeneration, their deflation—and in whatever sense one chooses to understand the term "ideas". A kind of amnesia is involved here, but it is a physical amnesia, an inhibition of the current that bears expression along. A sudden upset or blockage occurs, the lucid state produced by the active exercise of the mind is brutally dispelled, and ideas are thrown into turmoil because they cease being grasped, because of the dissipation and dispersal of who knows what vital magnetism. We enter a state of major confusion which we are tempted to blame on a chaos of the mind, that is, to treat the mind as a great unregulated mass, whereas in reality it is simply a void, and to seek remedy for what we assume to be a transient mental powerlessness, a momentary stumbling-block that can swiftly be corrected for by the psyche's central function. We try changing the object of our intellectual activity, imagining that such a change in orientation, by bringing the mind to bear on a new and better chosen realm, must perforce restore its vitality, but we are plunged instead into an atrocious despair, a despair rendered all the more frightful in that it centres on nothing, in that it is no longer connected to the general desiccation of the inner life of the emotions; a despair, too, that is truly absolute, because we perceive that it is the organ of intellectual activ-

ity itself that has suffered a trauma, that thought is degenerating, that the impulse to think has been prejudiced, that our animal magnetism is escaping in every direction, failing to overcome the obstacles in its path, petering out at its source, weakening with every renewed effort. What is more, although a belated analysis of our state of confusion and exacerbated weakness may be within our means, we are perfectly incapable of describing the dysfunctions it provokes or of showing how every component of the personality is drawn into the débâcle, how even the very feeling of the ego's existence is overwhelmed by this despair of the ego and its possibilities.

Something that Artaud and Péret had in common was a belief in archetypes. For both of them the impossibility of attaining total being or of acceding to the totality of language underlay a metaphysics in which a boundless solipsism allowed itself to be satisfied with entities pre-existent to all reality whose discovery and definition, and the modification of whose signs, are possible only by way of acts of clairvoyance. Thus Artaud's analysis of the hidden meanings to be found in rock formations, in his *Voyage au pays des Tarahumaras* [Voyage to the Land of the Tarahumaras], has a parallel in Péret's discusssion of the painter Wilfedo Lam (although Péret does feel the need for some kind of material underpinning):

> The true mission of the artist, whether painter or poet, has always been to rediscover within himself the archetypes that underpin poetic thought, and to reinvest that thought with a fresh emotional charge so that between himself and his peers a current of energy might be set in motion which will be all the more intense inasmuch as these reactivated archetypes emerge as the clearest and newest expression of the determining factors in his background.

Midway between Artaud and Péret, and given to voicing reservations about straightforward literary or pictorial work precisely

because his de facto positions tended to justify them, Breton devoted a great deal of his attention to the metaphor as such, that is, to the metaphor as an aesthetic factor.

An anti-aesthetic aesthete, Breton was often content to revive the worm-eaten attractions of modern art's graveyards. His famous slogan, "Beauty will be convulsive or will not be at all", is more valuable in itself than any of the examples he offers in support of it. Perhaps at some future high point in the final struggle this slogan will indeed become the watchword, but in the context of Surrealism itself it was never more than a glittering trace of subjectivity and of everyday adventure inscribed on the tattered fabric of the ruling language.

The first *Manifesto* proclaimed: "The marvellous is always beautiful, anything marvellous is beautiful, in fact only the marvellous is beautiful." We were already in the land of Fantomas versus Lafcadio, Nerval versus Lamartine, Jarry versus Zola—the land, in short, of everything that now constitutes left-wing culture: clearer ideas in the service of a more general idiocy.

In Breton's mind the marvellous was also the foundation of the cult of the metaphor, casting beauty in a new light. Metaphors, of which the whole of Surrealist poetry (in the narrow sense) is a many-splendored celebration, combine two sparks: the spark, produced by the interaction of contrasting assemblages, which destroys congealed language, and the spark, produced by the clash of subjective symbols, which creates a new language. The two become one in the light of the metaphor, in the convulsiveness of beauty.

The system of metaphor and image in painting thus constituted an ideological ruse whereby Surrealism managed for a time to avoid the fallout of cultural fragments generated by the explosion of 1915-1920. This was what kept the movement apart from mainstream literary and artistic production, which was condemned, in a pitifully regimented way, to the rehashing of the end of the novel after Joyce, the end of painting after Malevich, the end of sculpture after Duchamp, and the end of everything after Dada. It was also the means whereby Surrealism successfully *concealed* both the bankruptcy

92

of culture as a separate and alienating sphere and the corollary need to advance from the archaic notion of a living art to the reality of an art of living.

Metaphor and image are self-sufficient. They are the basis of a cultural closed circuit whose seeming emancipation from the sway of culture is nothing but a mask for the fact that, so far from threatening culture's hegemony, it actually reinforces it. Quite apart from the contribution of the art of fascinating images to the growing voyeurism that attends the expansion of an economy of overconsumption which must display what it has to "offer" and can sell only what it displays, it is worth pointing out that appealing to the marvellousness of the metaphor system would be meaningless outside the context of an ideology taking on more and more esoteric overtones and tending to become indistinguishable from a hermetic doctrine.

Paradoxically (and rather as alchemy discovered sulphuric acid in a purely serendipitous way), the shift from the magic of language to the language of magic produced a genuine tool of demystification, namely the technique of diversion, or *détournement*. Admittedly Breton never defined this technique as precisely as the Situationists did later, as for example in *Internationale Situationniste*, Number 3 (December 1959):

> The two basic principles of *détournement* are the loss of importance, and in the extreme case the complete disappearance, of the original meaning of each independent diverted element; and, simultaneously, the organizing of another meaningful whole which confers a new significance upon each of those elements.

Breton merely observed—in *Point du jour* [Break of Day, 1934]—that "All things are bound to be put to uses for which they are not usually destined", but he certainly *applied* the principle of *détournement*, as for instance in "Notes on Poetry", written in collaboration with Paul Éluard (*La Révolution Surréaliste*, Number 12, 1929). Valéry had writ-

ten, "A poem must be a feast of the intellect", and "Poetry is a survival". These edicts now became: "A poem must be a disaster of the intellect" and "Poetry is a pipe". It is also worth recalling the humorous use made of *détournement* by René Magritte when he replaced the figures in classical paintings by coffins. In the absence of a global critique, the tactic was never explored further or applied to the revolutionary struggle. *Détournement* was one of the weapons Surrealism left behind for its heirs to put to as good a use as they could.

THE SAVAGE EYE AND THE CIVILIZATION
OF THE IMAGE

There were two reasons for Breton's violent reaction to Pierre Naville, when, as editor of *La Révolution Surréaliste*, the latter defended the idea that there could be no such thing as Surrealist painting: the requirement that the metaphor thesis be internally consistent, and the money that several of the Surrealists made by dealing in art. If Surrealist painting wished to demonstrate a commitment to radical positions or to revolutionary violence, it could not point, as poetry could, to a critical or mordant discourse of its own. On the other hand it was readily compatible with the same ideology as the metaphor, for, just like the metaphor's, its effect on the flow of discrete symbols and veiled wishes, as on the chance encounters of objective forms, was to produce condensations. And, unlike poetic writing, it had a market. Breton was well aware of this, and, while he invariably condemned the ostentatious pursuit of fame or wealth, he never made so bold as to define painting quite simply as a poetic occupation. Rather, he justified the Surrealist approach to the pictorial with the same arguments that he had used in connection with metaphor: just as words played and made love, so the eye "existed in its savage state" (*Surrealism and Painting*, 1928).

To proclaim the innocence of art in a period when art could be innocent only if it were transcended, only if it were realized, was to misapprehend the significance of Dada and to underestimate the fetishism of the commodity. The proposition that "the eye exists in its savage state" was self-glorifying in two equally unjustified ways. In the first place, this was a time when advertising and the news media (not to mention the fascist "happenings" of the moment) already knew perfectly well how to manipulate clashing images, how to milk "free" representations for all they were worth; it was therefore quite predictable that the ruling system would co-opt the new way of looking that Surrealism was so busily promoting. Secondly, it should have been plain—to any avant-garde worth the name at

least—that the organization of social passivity, in its concern to minimize the recourse to police and army, was bound to foster the consumption of increasingly lifelike and increasingly personalized images, the aim being that the proletariat should move only to the extent required for the contemplation of its own inert contentment, that it should be rendered so passive as to be incapable of anything beyond infatuation with varied representations of its dreams.

Painting was a privileged sector of Surrealist activity; it was also the sector most thoroughly co-opted by what the sociologists, in their eagerness to avoid any analysis of the spectacle and the commodity system, like to call "the civilization of the image". Thus, for all its appeal, Breton's statement of 1929, according to which "Oneiric values are clearly now preponderant, and I insist that anyone should be treated as an idiot if they still refuse, for instance, to see a horse galloping across a tomato", must be placed in the context of the image-as-object distilling the commodity's power to attract, concealing the alienating relationships that the commodity entails, and reproducing the commodity as pure ideological appearance.

There can be no doubt that by the end of the 1920s Surrealism had already unresistingly accepted the inflated value placed on vision. "Every day," said Man Ray, "we are the recipients of open confidences; our eye can train itself to comprehend them without prejudice or constraint." And here is the Czech Jindrich Styrsky: "My eyes are forever demanding that food be thrown their way. They swallow it with brutal eagerness. And at night as I sleep they digest it."

Marx used to say to Engels, as they strolled about London, "That's their Westminster, that's their Parliament", and so on. How is it that the Surrealists never realized that by painting "their" buildings (even had they devastated them with images of desire—something which they never did, there being in Surrealist painting nothing remotely comparable to Péret's *Je ne mange pas de ce pain-là*), that by painting "their" parks and covering "their" décors with faces out of dreams, they were just redoing the façade of the old world. Of course, this reproach would have no force whatsoever had not

Surrealism longed so passionately to be revolutionary.

When not repressed entirely by the Surrealists, the memory of Dada's radicalism manifested itself less in the form of scandalous images than in the form of techniques that placed painting within everyone's grasp. This is how Max Ernst described his discovery of "frottage" in 1925:

> Starting from a childhood memory...in which a fake-mahogany panel opposite my bed had served as an optical catalyst for a vision while half-asleep, and now finding myself at a seaside hotel on a rainy day, I was struck by the obsessive fascination that the floor, its cracks accentuated by uncounted scrubbings, was able to exercise upon my distracted gaze. I resolved to investigate the symbolic meaning of this obsession, and to assist my capacity for meditation and hallucination I made a set of rubbings of the floorboards, positioning sheets of paper on them at random and using graphite to bring up the pattern. When I carefully inspected the results, some areas of which were quite dark while others were but lightly shaded, I was taken aback by a sudden intensification of my visionary faculties, and by a hallucinatory sequence of contradictory images, each superimposed upon its predecessor with the persistence and speed that one associates with memories of love.
>
> Curious, indeed enthralled, I ended up using the same method to explore all sorts of materials that happened to enter my visual field: leaves and their veins, the frayed edges of sackcloth, the brushstrokes of some "modern" painter, thread unravelled from a bobbin, and so forth. My eyes then perceived human heads, various animals, a battle that ended up as a kiss (*The Fiancée of the Wind*), some rocks, *The Sea and the Rain*, earthquakes, the *Sphynx* in its stable, some *Little Tables Around the Earth*, *Caesar's Palette*, some *False Positions*, a *Shawl with Frost-Covered Flowers*, the *Pampas*, etc.

Thus in a sense frottage became the equivalent of automatic writing. "It is as a spectator", Ernst adds, "that the creator, whether

indifferently or passionately, witnesses the birth of his work and observes the stages of his own development." Instead, then, of emphasizing the possibility of a technique of this kind being used by all, Ernst stressed the painter's transformation into a passive spectator, insisting on the joy of contemplation and not on the joy of creation. It is hard not to conclude that the Surrealist painters felt threatened by any tendency to treat art as a game, and that, as painting and sculpture acknowledged their affinity with the world of childhood and were secularized by a spirit of playfulness, these artists suddenly sensed a challenge to their dignity—the dignity of honours and profit—and felt obliged to move heaven and earth if need be to make sure their products did not lose the aura of the sacrosanct.

Breton's description (1936) of decalcomania, invented by Oscar Dominguez, betrays the same urge to reduce the technical relics of Dada's dissolution to a Surrealist "magical art":

> Children have traditionally enjoyed folding sheets of paper after blotting them with wet ink so as to produce the illusion of animal or vegetable entities or growths, but the elementary technique of which children are capable is far from exhausting the resources of such a procedure. In particular the use of undiluted ink excludes any surprises in terms of "substance" and limits the result to a contoured design which suffers from a certain monotony resulting from the repetition of symmetrical forms on either side of an axis. Certain wash-drawings by Victor Hugo seem to provide evidence of systematic explorations in the direction which concerns us here; certainly an extraordinary power of suggestion is obviously expected to emanate from the entirely involuntary mechanical details which predominate, but the results are mostly limited to Chinese shadows and cloudy apparitions. Oscar Dominguez's discovery brings precious advice on the method to follow in obtaining ideal fields of interpretation. Here we can rediscover in all their purity the rocks and willows of Arthur Rackham which enchanted us when we were about to leave childhood behind. Once again, we are offered a recipe *within*

everybody's grasp, a recipe which demands to be included among the "Secrets of the magical surrealist art" and which may be formulated as follows:

*In order to open one's window at will upon
the most beautiful landscapes in this or any other world*

With a broad brush, spread some black gouache, more or less diluted in places, on a sheet of white glazed paper and then cover this immediately with a similar sheet which you will press down lightly with the back of your hand. Take this upper sheet by one edge and peel it off slowly as you would do with an ordinary transfer, then continue to reapply it and lift it away again until the colour is almost dry. What you have in your hands now is perhaps nothing more than Leonardo's paranoiac ancient wall, but it is this wall perfected. All you need do now is study the resulting image long enough for you to find a title that conveys the reality you have discovered in it, and you can be quite sure of having expressed yourself in the most completely personal and valid manner.

The technique of *détournement* was likewise incorporated into the alchemy of Surrealism's pictorialists, and thus rendered "occult" instead of being popularized in every form, as by rights it should have been.

The painters' clique in Surrealism was much prone to apoliticism in the strict sense, and together with the neo-*littérateurs* constituted the right-leaning fraction of the movement. Aside from a handful of mediocre camp-followers, most of the Surrealist painters "succeeded"; few among them displayed any scruples as to how their success was achieved, and many had no hesitation about quitting the group as soon as they were launched—or as soon as the lackeys of the old world tossed them a bone.

Inasmuch as Surrealism did indeed inherit from Dada the project of the transcendence of art (and even if it dealt with this inheritance solely on an abstract plane), it is to two non-Surrealist painters, Giorgio de Chirico and Paul Klee, that credit should go for conveying the unconscious memory which made the agonizing décor of our

reification and the return to the sources of creativity into essential aspects of Surrealism's most important artistic works. No one better than de Chirico (though he soon retreated into senility like Rimbaud fleeing to Harar) has perceived the invasion of *things*, the proliferation of stucco, the spread of human absence, the disappearance of faces, and the increased burden of anxiety borne by the cheap goods and theatrical props that crowd around us. No one better than Klee, with his ever vigilant intelligence, has captured the movement of creativity in its full freshness and spontaneousness; his work may well one day serve, just like Péret's, as one of the finest avenues open to future generations wishing to understand the culture of the past.

Surrealist painting pitched its tent between the two pinnacles represented by de Chirico and Klee on the one hand and the Dadaist abyss on the other. Max Ernst decked de Chirico's angst with his characteristic mineral concretions and luxuriant vegetation; Miró redid Klee in a fake-childish and more sophisticated manner; and Magritte, the painter most concerned with the image as poetic metaphor, offered the best response to the idea of a window opening at every instant onto a strange everydayness and its objects— objects which every human dreams of humanizing.

Among the *"littérateurs"*, Picasso, a tireless and tedious creator of gimcrackery who eventually indeed "hooked us by sheer quantity", stands elbow to elbow with the canny Dalí, whose work, dedicated to the greater glory of the moronic, the deliquescent and the impotent, resonated remarkably well with the softening-up techniques of the society of the spectacle, and as a corollary ensured Dalí support from the most highly placed cultural and media functionaries.

There is a sense in which Dalí epitomizes both the failure and the success of Surrealism: on the one hand the derailing of creativity as a revolutionary force, on the other a seamless integration into the old world. Never opting firmly either for a poetry made by all or for the venality of the ruling system, Surrealism took something of both and produced an impoverished cultural hodgepodge. The movement's entire discourse is one long self-consolation whose growing

pathos, accompanied by an ever more pressing appeal to the mists of magic, becomes only too comprehensible when we hear Breton condemning the dictatorship of the rational and calling instead for "machines of most ingenious design destined for no particular use" (a call which Tinguely, for one, would answer, constructing just such machines without, however, remotely affecting the ever tighter grip of the rationality of *things*); or, again, when we find Jean Schuster, in 1969, quite willing to write that "All images are dangerous, because they facilitate the circulation of ideas."

As for Surrealist films, there is not much to be said, save perhaps that the movement's two masterpieces, *Un Chien andalou* and *L'Âge d'or*, had a profound influence on the cinema. (*Dreams That Money Can Buy*, by Man Ray, Hans Richter and Max Ernst, is a film that deserves to be better known in France.) *L'Âge d'or* embodied a violence, albeit one cloaked in aestheticism, that seemed at the time to presage a later development in which the Surrealist film, by taking its distance from the pictorial perspective, would achieve formidable agitational and demystificatory power. But everyone knows what became of Dalí; and Buñuel became what one might have feared for anyone who takes pride in being called a *cinéaste*.

CHAPTER 5

CONVERTING TO MYSTICISM

RECONSECRATION

No sooner had ascendant bourgeois power, thanks to the arms of criticism and criticism by arms, successfully shattered the unity of the old social and religious myth, than the new rulers felt the urgent need to reinstitute an organization of appearances—a universal *representation* of the individual freedoms so essential to the conduct of business—that could provide a justification for their function as an exploiting class. The tentacular expansion of the economy—nerve-centre of the bourgeoisie just as it would later be of the ruling caste of the socialist State—was not easily reconciled, however, with recourse to a god, to a mysterious unity which the new conditions of social atomization could not in any case either resuscitate or maintain.

By the beginning of the twentieth century art had been effectively annexed by the general system of the economy, and no choice remained to it save that between self-transcendence, which is to say its actualization as a mode of life in a society without hierarchies, and a slow agony. Dada had an awareness of the negative but not of the necessity of such a transcendence; Surrealism was aware of the necessity of transcendence but not of the necessity of negativity. In both cases the dice were loaded, but only Surrealism must be held to account by history for its reactionary attempt to restore to art a life that it no longer had, a life whose very memory was already lost to it. (We have already noted the great store that Surrealist art set by great names and great moments of the past, by their living relevance and by the need for them to be remembered.)

Little by little, as the dream of revolution broke up on the reefs of nascent Stalinism, but also as the society of the spectacle and of the commodity system inevitably co-opted anything that could be called artistic, Surrealism retreated to the heights of pure mind. From a fortress open to every wind blowing in from the old world, it began—after the fashion of the Romantics reinventing an idyllic Middle Ages, complete with valiant knights, in the very shadow of the stock exchanges, banks and factories—to entertain the fantasy of

a powerful myth, stripped of any religious overtones, that would combat the poverty of the spectacle and that would draw its strength from a reconsecration of human relationships modelled on the reconsecration of art.

It would be hard to outdo this as sheer contempt for history. Not that such a project could absolutely never be made into reality for a time: after all, the Nazis launched a comparable operation, albeit one orientated in a diametrically opposed direction, when they sought to return to the reign of myth by reconsecrating everything that the Surrealists shat upon from the greatest height: the Fatherland, the Army, the Führer, the State, etc. As confused as they may have been, the Surrealists remained committed in the pre-war period to the destruction of capitalism in both its private and its State versions; they had not renounced the hopes they placed in the "final struggle", and they threw down the gauntlet in all sincerity to whatever served to sustain and modernize the exploitation of the proletariat.

The position of Surrealism after the Second World War flowed from a despairing view of history. This view was based on the successive defeats of a workers' movement whose revolution the Surrealists had awaited passively in the expectation that it would resolve their own problems. Breton himself offers a clear account of this in "Prolegomena to a Third Surrealist Manifesto or Not" (1942). He begins by evoking the failure of supposedly "emancipatory" systems:

> Though I am only too likely to demand everything of a creature I consider beautiful, I am far from granting the same credit to those abstract constructions that go by the name of systems. When faced with them my ardour cools, and it is clear that love no longer spurs me on. I have been seduced, of course, but never to the extent of hiding from myself the *fallible* point in what *a man like me* holds to be true. This fallible point, even though it is not necessarily situated on the line traced for me by the original teacher during his lifetime, always appears to me to be located somewhere further along this line as extended through others.

This failure is explained without the slightest allusion to the critique of hierarchy, without ever addressing the question of the mechanisms of co-optation:

> The greater the power of this man, the more he is limited by the inertia resulting from the veneration that he will inspire in some and by the tireless activity of others who will employ the most devious means to ruin him. Aside from these two causes of degeneration, there is also the fact that every great idea is perhaps subject to being seriously altered the instant that it enters into contact with the mass of humanity, where it is made to come to terms with minds of a completely different stature than that of the mind it came from originally.

There is also the unreliability of comrades-in-arms to be considered:

> The evils that are always the price of favour, of renown, lie in wait even for Surrealism, though it has been in existence for twenty years. The precautions taken to safeguard the inner *integrity* of this movement—which generally are regarded as being much too severe—have not precluded the raving false witness of an Aragon, nor the picaresque brand of imposture of that neo-Falangist bedside-table Avida Dollars.

And Breton is galled by the general alienation of the movement:

> Surrealism is already far from being able to cover everything that is undertaken in its name, openly or not, from the most obscure teashops of Tokyo to the rain-streaked windows of Fifth Avenue, even though Japan and America are at war. What is *being done* in any given direction bears little resemblance to what was *wanted*. Even the most outstanding men must put up with *passing away* not so much with a halo as with a great cloud of dust trailing behind them.

Breton's disarray of 1942 still embodies much of the despair felt by Artaud in 1925. In *Le Drame du surréalisme*, Victor Crastre presents

a somewhat cavalier explanation of Artaud's lack of enthusiasm for meeting the *Clarté* people: "His unhealthy passion for being tormented, his taste for failure, even for catastrophe, prohibited him from searching for a social form of revolt, from conceiving of any optimistic plan for the transformation of the world." It would doubtless have been more to the point to inquire whether Artaud's vocation for failure did not stem rather from an instinctive rejection of history at a time when history gave every appearance of having been monopolized by the Bolsheviks. In view of this halt imposed on human emancipation in the name of the proletariat itself, it is not hard to understand that a lucid but isolated mind, and one in any case cut off from whatever left-wing opposition to Bolshevism still existed, should have apprehended historical consciousness as a consciousness of a void and as the utter negation of any individual history.

Artaud proceeded, alone, along a path that Breton would later impose on the Surrealist movement under much less dire circumstances. The tragic myth that Artaud constructed in order to cope with his state of self-division was something which in that early period he had to confront without the backing even of what Surrealism would eventually achieve, namely a real history which, as alienated as it may have been, did contrive to be at once collective and individual. Artaud's decision is registered in his *Le Pèse-nerfs*, where he talks of "bringing myself face to face with the metaphysics that I have created for myself on the basis of this nothingness that I carry within me", and, when he writes in the third issue of *La Révolution Surréaliste* that "Through the rents in what is henceforward an unliveable reality speaks a wilfully sibylline world", there is a clear intimation that he intends to devote his life to the deciphering of that "world".

Not long afterwards, the Grand Jeu group would briefly embrace the same anguished hope for a renewal of myth before succumbing to the charms of esotericism, Zen, and Gurdjieff. When it came Surrealism's turn to tread the path of mystical retreat, it has to

be said that it was better armed for it—armed, as it were, by a higher tally of failures....

First of all, Surrealism, in its attempt to salvage art, had already experienced the call of the sacred, the attraction of magic, the taste for the mysterious and the temptations of the hermetic tradition. It had pursued all of them to a degree, while continuing to focus most of its attention on the adventure of love, the exploration of dreams, creative activity, everyday life, and revolution.

Compromise with Communism certainly threatened the very soul of Surrealism. So much so, in fact, that Breton felt obliged (in 1929) to write:

> I fail to see, whatever certain narrow-minded revolutionaries may think, why we should refrain from addressing the questions of love, dreams, madness, and so on—provided always that we place them in the same perspective as that from which they (and indeed we too) envisage the revolution.

One of Surrealism's chief faults, and one for which even the movement's basically ideological character cannot be blamed, is that it handed over all responsibility for the universal revolutionary project to Bolshevism, which, hewing fast to the logic of Lenin's work, had never done anything but undermine that project.

Although Breton did not concede any part of what he rightly considered to be fundamental, he could not help feeling that the break with the orthodox Communists represented a moving away from the historical possibilities opened up at "privileged" moments of everyday life. This was truly an instant when ideology came into play in the most striking manner, with all its power to turn the world on its head: the demands of subjectivity, never yet made the basis of the actual revolutionary movement, were now transformed into the abstract underpinnings of an ideology which the critical-*cum*-practical action of real history would have utterly dispelled, but which Lenino-Stalinism merely dubbed a "solipsistic ideology", and excluded on that basis from its own pseudo-revolutionary practice (i.e., the practice of the bureaucrats).

The revolutionary feels despair when confronted by the trans-
formation of real historical movement into ideology. The Surrealists
despaired on two counts: as would-be revolutionaries, they had an
inkling of the revolutionary's despair; at the same time they felt the
despair of the ideologues they were at being excluded from the rul-
ing revolutionary ideology (the Bolshevism of the 1930s). Little
wonder that they saw no other way forward than resolutely to
embrace a mysticism founded on their earlier but since repressed
commitments.

Surrealism thus plumped for a mystique of life, and of the lifting
of repression, just when Nazism, at the culmination of a period dur-
ing which the German people had demonstrated their own inclina-
tion to leap into unreality, was promoting a mystique of death and
repression.

Georges Bataille was clearly aware of this when he called for the
living forces of Surrealism to be thrown simultaneously into the
struggle against fascism and into the struggle against the Stalinist-
run antifascist fronts. This idea, in any case somewhat dubious, was
a nonstarter.

The time had come, so far as the Surrealists were concerned, to
listen to Artaud's words from an earlier day:

> Enough language games, enough syntactical tricks, enough
> word-juggling and phrase-making! We must now seek the
> great Law of the heart, that Law which is not a Law, not a
> prison, but a guide for the Mind lost in its own labyrinth.

Surrealism's turn to metaphysics, however, was not just a response to
individual confusions or to a particular set of circumstances. The
painters' lobby, never much interested in the political debate, was
much relieved to see the movement taking a mystical tack. Already
attached to the notion of the magic of the creative act, this tenden-
cy had everything to gain from a revitalization of myth centred on
the idea of beauty and on art as a mirror of the marvellous. Such a
perspective would allow the painters to devote themselves entirely

to matters aesthetic while loudly denying any concession to aestheticism. Their influence on Surrealism's change of course was certainly not negligible.

At all events, the appearance of "Prolegomena to a Third Surrealist Manifesto or Not", in 1942, clearly marks the shift to a purely metaphysical position. The conclusion of this text, in particular, gives the measure of the new orientation; it also exposes the close kinship between that orientation and the goals earlier set for himself by Artaud. Under the heading "The Great Transparent Ones", Breton writes:

> Man is perhaps not the center, the cynosure of the universe. One can go so far as to believe that there exist above him, on the animal scale, beings whose behavior is as strange to him as his may be to the mayfly or the whale. Nothing necessarily stands in the way of these creatures' being able to completely escape man's sensory system of references through a camouflage of whatever sort one cares to imagine, though the possibility of such a camouflage is posited only by the *theory of forms* and the study of mimetic animals. There is no doubt that there is ample room for speculation here, even though this idea tends to place man in the same modest conditions of interpretation of his own universe as the child who is pleased to form his conception of an ant from its underside just after he has kicked over an anthill. In considering disturbances such as cyclones, in face of which man is powerless to be anything but a victim or a witness, or those such as war, notoriously inadequate versions of which are set forth, it would not be impossible, in the course of a vast work over which the most daring sort of induction should never cease to preside, to approximate the structure and the constitution of such hypothetical beings (which mysteriously reveal themselves to us when we are afraid and when we are conscious of the workings of chance) to the point where they become credible.
>
> I think it necessary to point out that I am not departing appreciably from Novalis's testimony: "In reality we live in

an animal whose parasites we are. The constitution of this animal determines ours and vice versa," and that I am only agreeing with a thought of William James's: "Who knows whether, in nature, we do not occupy just as small a place alongside beings whose existence we do not suspect as our cats and dogs that live with us in our homes?" Even learned men do not all contradict this view of things: "Perhaps there circle round about us beings built on the same plan as we are, but different, men for example whose albumins are straight," said Emile Duclaux, a former director of the Pasteur Institute (1840-1904).

A new myth? Must these beings be convinced that they result from a mirage or must they be given a chance to show themselves?

As fantastic as Breton's hypothesis may appear at first sight, it casts an unblinking eye on the posture of Surrealism in its final period. It flows from the same judgement as that made by the Nietzsche who exhorted us to embrace an *amor fati*—to love our fate. It postulates that we have to choose between submission to the wretched vicissitudes of everyday life and a vow of fealty to mysterious forces that intervene in the guise of luck or ill luck in the enterprises of the individual will. These forces (and it is easy to see how duplicitously individual subjectivity, once deprived of its material and historical prospects of self-realization, will invent, while feigning to discover them) do not supposedly require us to reconcile ourselves with them by means of religious or magical rites; rather, our task is to provoke their emergence through a patient decanting of all our faculties, all our senses. This is an alchemical procedure, in fact, its goal the goal once sought by the hermetic tradition; and, sure enough, from this point on the hermetic thinkers would be inducted in force into the Surrealist pantheon.

The most cursory reading leaves us in no doubt that Breton is implicitly positing the permanence of human alienation, asserting that there is no way of ever disentangling ourselves from its thrall. And upon this basis he proceeds to set up an opposition, and a con-

flict, between the presumed positivity of a sacrosanct alienation and the negativity of the alienation of the present, alienation as an immediate datum of our current state of survival under the rule of the spectacle.

Thus the Surrealists took up the defence of myth, at a time when myth no longer existed, against the spectacle, which was everywhere. They were Don Quixotes tilting against housing projects; no one in that time of change so much resembled the Cervantes character as these latterday knights wandering between the devil of total freedom and the death of culture.

To these ageing men, sclerotic from so many defeats yet still animated by an unshakeable enthusiasm, the parallel and mentally accessible universe of gods and heroes of myth and legend held out the prospect of intellectual adventure via the concrete activity of the creator and discoverer of meanings, via the invention and celebration of obscure guides, via the athanor of all the Great Works of the possible.

The best analogy here is not hard to find, for it lies in the epic and world of the Celts, for whom the Surrealists now conceived a most vigorous admiration, as witness Jean Markale's account of *L'Epopée celtique en Bretagne* [The Celtic Epic in Brittany]:

> First there is the Quest, that is to say the search (in every sphere, but most especially with respect to Man's equilibrium and happiness) for complete harmony with nature. But happiness is achieved only after a whole series of trials—the trials of life itself, violent, hard, and bloody; only then does Man come to know, does he learn the miraculous formula that allows him to face his destiny, for this miraculous power can be taught by no one: only he himself has the ability to make it out, piece by piece, along the roads he travels, in battles haunted by death, in the victory that he holds in his hands.
>
> Then there is the quest for Woman, the Chosen One, who at times takes on a different countenance the better to lead Man astray, the better to make him prove his worth,

the better to metamorphose him. For the woman of the Breton epic is necessarily a fairy, a goddess: she has powers that no man can snatch away from her, although she may bestow them, if she so wishes, upon a man of her choosing. For Woman is ever sovereign, whether she is a mere servant girl or one of those mysterious maidens who so often make their appearance in some castle looming from the shadows of the night only to vanish come morning into the mists of memory.

There is also what is called the Quest in the Other World, the search for the treasures hidden in that World, which cannot be very far away, since it is everywhere present—at every twist in the road, in a valley dominated by a castle, in a forest clearing, or on a mound blasted betimes by storms whose wild lightning flashes transform the landscape. This is a permanent descent into hell, into Man's deepest core, into the shadowiest lands of his consciousness, his imaginings and his dreams. But we always return, for mind always triumphs over matter. Death itself does not exist: it is denied. Arthur slumbers yet on the Isle of Avalon or in some cavern beneath the earth: he will return.

All the characteristic themes of Celtic literature supplied the base material out of which post-war Surrealism dreamt of constructing a new mythical imagery. These themes had of course been present in Surrealism from the beginning, complete with their sacred aspect. The turn towards the Beyond, towards the immanence of the myth-to-be-lived, meant a return to love, dreams, madness, childhood, the savage eye, mineral coincidences, the alchemical tradition, the art of the South Seas, of the Indians, of the Celts, mediumistic experimentation, automatism, etc. And all of them were now flung together in a veritable whirlwind of consolidation.

When he discovered Fourier's work, Breton saw it primarily as a "hieroglyphic interpretation of the world based on the analogy between the human passions and the products of the three realms of nature." In "On Surrealism in Its Living Works" (1953), he was more specific:

The mind then proves to itself, fragmentarily of course, but at the least *by itself*, that "everything above is like everything below" and everything inside is like everything outside. The world thereupon seems to be like a cryptogram which remains indecipherable only so long as one is not thoroughly familiar with the gymnastics that permit one to pass at will from one piece of apparatus to another.

In the general conversion of Surrealist values, which was governed by the hope of instituting a mythical edifice capable of fostering new forms of action, the importance of language remained cardinal, particularly the importance of poetic intuition, which,

> finally unleashed by Surrealism, seeks not only to assimilate all known forms but also boldly to create new forms—that is to say, to be in a position to embrace all the structures of the world, manifested or not. It alone provides the thread that can put us back on the road of Gnosis as knowledge of suprasensible Reality, "invisibly visible in an eternal mystery".

Prevented by its ideological nature from acceding to a critical use of language, and at the same time declining to engage in any effective critique of the ruling language, Surrealism ended up defining itself as a quest for the original, magical kernel of things, for what might be called the language of the gods. As Breton put it, "The whole point, for Surrealism, was to convince ourselves that we had got our hands on the 'prime matter' (in the alchemical sense) of language"—in other words, language in its primitive form, as it existed prior to any distinction between speech and discourse. As for the kind of intelligence that made such a return "possible, and even conceivable", it was, in Breton's view, "none other than that which has always moved occult philosophy".

In the 1940s the painter Wolfgang Paalen came to a similar conclusion with respect to pictorial language. Asking "What to paint?", Paalen suggested that artists should attempt the "direct visualization

of the forces that move us, both physically and emotionally". He called this approach a "plastic cosmogony".

The texts that Desnos and Crevel had dictated while plunged into mediumistic trances back around 1925 were now seen as operating in very much the same way as the manuals of the alchemists. For Surrealism, this was evidence of the movement's kinship with the hermetic tradition. Mythically restored, the unity of language and world meant that different kinds of phenomena could now be put on the same plane and so become subject to associations and correspondences. The sharpest attention was paid, however, to premonitions, objective chance and the various forms of occultism for which Surrealism had always had a latent affinity.

Breton had already been struck (as he recounts at length in *Mad Love*) by the accuracy with which his poem "Sunflower" (1923) foretold the circumstances of an especially significant romantic encounter of his:

The traveler passing through the Halles at summerfall
Was walking on her tiptoes
Despair was swirling its great lovely calla lilies in the sky
And in the handbag was my dream that flask of salts
Only God's godmother had breathed
Torpor spread like mist
At the Smoking Dog Café
Where the pro and the con had just come in
The young woman could scarcely be seen by them, and only askance
Was I speaking with the ambassadress of saltpeter
Or of the white curve on black ground that we call thought

Breton cites several other disconcerting coincidences, among them de Chirico's circling of Apollinaire's temple in a portrait done long before the poet, after being trepanned, was obliged to cover the spot with a leather patch; or, again, the large number of canvases in which Victor Brauner recorded a haunting obsession with ocular mutilation just shortly before an accident that cost him an eye. All

116

such events would now constitute a whole for the Surrealists—a whole nowhere better exemplified than in the dream.

Recounted or analysed, dreams now became either literary objects or the subjects of common-or-garden Freudian interpretation. Aside from their admiration for Ferdinand Cheval, who had well and truly set about realizing his dream in the shape of his Ideal Palace, the Surrealists never developed the perspective of the practical realization of dreams much beyond vaguely prophetic edicts: "The poet of the future", according to Breton and Éluard's *Dictionnaire abrégé du surréalisme* (1938), "will surmount the depressing idea of an unbridgeable gap between actions and dreams." The turn to mysticism resolved this tension solely on the plane of an abstract coherence. In the first place, the dream was the marvellous in microcosm, lying within everyone's reach. As Paraclesus recommended, "Let all examine their own dreams, for each is his own interpreter." Here was the individual's way of initiation into the "practice" of myth, a way which opened (and this is the second point) onto a panoptical prospect, in accordance, once again, with Paracelsus: "For I tell you, it is possible to see everything through the mind" (*Philosophia occulta*). Myth was thus the ideal precondition for the expansion of the dream universe, the unreal reality of a fundamental unity of self and world—that state which Karl Philipp Moritz had described in his *Fragmente aus dem Tagebuche eines Geistersehers* [Journal of a Visionary, 1787] as "the ineffable joy of finding myself outside myself.... I had lost all sense of place—I was nowhere and everywhere at the same time. I felt delivered from the order of things, or thrust out of it, and I no longer had any need of space."

It was perhaps, once again, Benjamin Péret who offered the most ominous account of this dream system, at the same time putting his finger on its point of potential self-transcendence, its internal need for objective realization: "Heard in the morning on 20 May last, in a half-slumber punctuated by confusing images of the Aragon front, which I had left three weeks earlier, the following sentence shook me sudden-

ly awake: *Durruti's egg will hatch."* There can be no doubt at all that in Péret's mind every possible measure had to be taken to fulfil (or to ensure that others would someday fulfil) this dream-borne prophecy.

The Surrealist exploration of human limits and potentialities likewise felt the impact of the change to a mystical vision of things. The experimental approach to the human was replaced by a purification of the ego by virtue of the alchemical Great Work. Concrete problems of subjectivity became problems of being. This ontological shift implied a movement from internal to external and evoked a cosmic unity divested of all anthropocentrism where the forces of the mineral, vegetable and human worlds all had their parts to play—a universe where, in René Guénon's formulation, as approved by Breton, "historical facts have no value save as symbols of spiritual realities". This view, which tended towards an absolute objective idealism, was to find its poet in Malcolm de Chazal, whose sensitive analytical powers and mastery of general metaphors are displayed in his *Sens plastique* (1947).

Lastly (though this does not exhaust the avenues pursued by the Surrealist "quest"), we must note the metamorphosis of the passion of love into a veritable cult of Woman. In this connection a passage from Michel Leiris's *Le Point cardinal* (1925) clearly foreshadowed what was to come:

> Then I saw that the Ingénue, her eyelids still lowered, was drawing my attention by means of an obscene motion of her hand to the portal of her thighs. I concluded from this gesture that I was being shown the only way out of the bedroom that remained open to me.

For mad love, with the possibility of its actualization blocked by historical upheaval, and considering the disgust it implied for what Breton called "the amorous ideal of pseudo-couples ruled by resignation and cynicism and hence embodying the principle of their own disintegration"—for mad love, the only way out was a mutation into sublime love, based on a consecration of the female genitals

(which myth lost no time investing with the meanings of life and death, of penetration and of chthonian depths, of the visible and the hidden, of air and earth, and so forth).

Thus Breton's hymn to the glory of Melusina, in *Arcanum 17*, betokens an abandonment of the love celebrated in *L'Amour fou*:

> Love, only love that you are, carnal love, I adore, I have never ceased to adore, your lethal shadow, your mortal shadow. A day will come when man will be able to recognize you for his only master, honoring you even in the mysterious perversions you surround him with.

That love gives way, though with no explicit acknowledgement, to the mystery of Woman, lost only to be found once more, uniting in her person all the contradictions of the world:

> Melusina after the scream, Melusina below the bust, I see her scales mirrored in the autumn sky. Her radiant coil twists three times around a wooded hill, which undulates in waves that follow a score where all the harmonies are tuned to, and reverberate with, those of the nasturtium in bloom....
> Melusina below the bust is gilded by all the reflections of the sun off the fall foliage. The snakes of her legs dance to the beat of the tambourine, the fish of her legs dive and their heads reappear elsewhere as if hanging from the words of that priest who preached among the scorpion grass, the birds of her legs drape her with airy netting. Melusina half-reclaimed by panic-stricken life, Melusina with lower joints of broken stones or aquatic plants or the down of a nest, she's the one I invoke, she's the only one I can see who could redeem this savage epoch.

The monogamous inclination of most of the Surrealists was herewith offered a transcendent justification far better suited to it than an anti-libertine ethic which had occasionally taken on an unpleasant authoritarianism and often turned into a hypocritical glorification of fidelity, and by extension of jealousy. Responding to

Péret's injunction, in his *Anthologie de l'amour sublime*, to "hail woman as the object of all veneration", Breton wrote:

> It is solely on this condition, according to him, that love can come to be incarnated in a single being. It seems to me personally that such a process cannot be fully concluded unless the veneration of which the woman is the object is not shared at all, because that would amount for her to a kind of frustration.

Some day the dubious aspect of restrictions of this sort will need to be clarified in the light of the notion of sacrifice—the pillar of all religions, and most especially of the Christian one. The fact is that Breton never attacked this notion, indeed on occasion he embraced it with a will.

AN ANTI-CHRISTIAN ECUMENISM

One question must have arisen very soon for those seeking the consecration of Surrealist values in the attempt to reconstruct a new mythic unity: how were the very notions of the sacred and the mythical to be separated out from religious systems? The boundaries are certainly difficult to fix, and perhaps when all is said and done it scarcely matters whether reference is made to Celtic heroes, or to the virtues extolled in the Sagas, rather than to Jesus Christ. Be that as it may, Surrealism, which is hardly open to the charge of indulgence towards Christianity, cannot, simply by preferring the here-below to the Beyond, evade the reproach, which it ought to have addressed to itself, that by plunging into the mists of the transcendent it was at the very least abandoning all hope of changing life and, concomitantly, transforming the world—a hope that it had always previously sustained, even if the movement's ideological nature precluded any genuine practical pursuit of it. It is not possible for myth to operate today: there is only the spectacle, and the spectacle alone rules. Placed now in a perspective so strongly inclined to put socio-economic conditions in brackets, the Surrealists' opposition to religion was bound to lose much of the force it had had in *Le Surréalisme au Service de la Révolution*, or for Péret, and it soon took on the ambiguous character of an anti-religious ecumenism.

In December 1945, in his *Supplément aux Lettres de Rodez*, Artaud proclaimed: "As for me, Artaud, I have no use for God, and I refuse to countenance anyone's founding a religion on my backbone or on my brain." This pronouncement did not prevent a few rumour-mongers from putting it about that Artaud had undergone a conversion. It was against this calumny, the model for which Paul Claudel had supplied with his attempt to co-opt Rimbaud, and versions of which had recently been directed in an equally outrageous manner at de Sade and Nietzsche, that the Surrealist pamphlet of 1948, *À la niche les glapisseurs de Dieu!* [Back to the Kennel with God's Yapping Dogs!]

was a well-justified protest. But what is one to think of the fact that only shortly afterwards Breton and his friends went along with a blatant attempt to co-opt Surrealism by the Christian Michel Carrouges, with whom they eventually broke off solely on the basis of internal disagreements?

The same kind of uncertainty was displayed by the Surrealists with respect to two essentially desacralizing strategies, namely the ludic mode and black humour. The older Surrealism grew, the more seriously it took itself. A playful spirit still often presided over the creation of works of art, but care was always taken that this spirit should never, as would have been consistent with its own logic, go so far as to destroy such works, to destroy their value by changing the rules of the game. Likewise, black humour, in essence a corrosive and negative force, as when it informed the behaviour of an Arthur Cravan, a Jacques Vaché or a Jacques Rigaut, now became nothing more than a critical aspect of a particular work. As negative and critical as it might be in that integrated role, it was never allowed to challenge art itself. Indeed Breton went much further in this direction, intimating in his *Anthologie de l'humour noir* that there was such a thing as an "art" of black humour. Let us be clear, however: the texts assembled by Breton in his anthology, and thus made available to all, were undoubtedly of a highly explosive nature, and the Vichy government was quite right to ban the book; but treating black humour as nothing more than an aesthetic category was in effect to suppress the instructions for the proper use of these texts and to obscure their true character, for they were the foam of a rage built up over the centuries against all forms of oppression, a rage that must in the end be unleashed, otherwise every kind of conformism would be able to drape itself in the robes of the extraordinary, and welcome subversive laughter with open arms.

From a mystical viewpoint, play is ritual and black humour resembles the devilish figures that the Church was cunning enough to retain in its architecture, even going so far as to carve them on the capitals supporting church roofs.

Is this to say, then, that Surrealism emerged from the Second World War as a purely speculative system? Yes and no. Paradoxically, the more successful Breton and Péret were in giving their movement the aspect of a mythic construct that had somehow strayed into the present, the more they helped nourish a certain sense of life, a sense that was repeatedly rediscovered during the series of revolutionary outbursts that began in 1968. In this way the eruption of life that had characterized Surrealism's earliest days, and then facilitated the movement's own eruption into cultural survival, now once more came to the fore in its original form, at once hastening the demise of culture as a separate sphere and helping to topple the mythic system of Surrealism itself. This collapse had to wait on the disappearance of Breton and Péret, however, for so long as they lived they were able, thanks to the authenticity of their own odyssey and thanks to their determination to fix their system firmly in place as a sort of centre of effort *for all eternity*, to infuse Surrealism with an appearance of life and turn it into an effective veil over reality.

If we bother to trace such resurgences of life through their various inverted manifestations in art and literature, we find that they flag and conserve all the diverse experiences whose more or less vivid traces humanity has left in its various cultures. It was as though Surrealism, on the eve of upheavals in which the will to live would throw the corpse of culture onto a joyful pyre, had wanted to save everything from past culture that was worthy of reincarnation in new forms of existence. The movement's attempt at synthesis, inciting us as it does to retrieve every single passionate *bizarrerie* of intellect or custom, must surely count as one of the greatest legacies of this century.

If there is any truth to the notion that the drowning see their whole life replayed before their eyes in a few short seconds, Surrealism might well be described as the last dream of a foundering culture.

Amidst the profusion of riches thus left in our care by Surrealism, the contribution of Lotus de Païni has the merit of going further back in time than any other. Her half-intuitive, half-reasoned analyses seek to ascertain what primitive mankind's structure of "feel-

ings"—meaning a unity of thought, sensation, emotion and action—must have been, this on the basis of cave paintings whose very existence already betokens the breaking up of that unity. It was surely not by chance that this search for "knowledge of the soul of those far distant from us" was conducted at a time when the necessity for a new "structure of feeling", for a multidimensional and unitary life, was making itself acutely felt. A strange figure, who never participated directly in their movement but whom the Surrealists discovered and hailed, Lotus de Païni seems to quit the paths of the imagination in order to offer the revolution the *poetic totality* of the old world.

CHAPTER 6

NOW

Today Surrealism is all around us in its co-opted forms—as consumer goods, art works, advertising techniques, alienating images, cult objects, religious paraphernalia and what have you. As much at odds as some of these multifarious forms may seem to be with the spirit of Surrealism, what I have been seeking to convey is that Surrealism indeed "contained" them all from the beginning, just as Bolshevism was "fated" to generate the Stalinist state. Surrealism's curse was its ideological nature, and it was forever condemned to try and exorcise this curse, even going so far as to replay it on the private and mystical stage of the myth of old, duly exhumed from the depths of history.

Surrealism had the lucidity of its passions, but it never conceived a passion for lucidity. Somewhere between the artificial paradises of capitalism and socialism's pie in the sky, it created a space-time of uncomfortable detachment and blunted aggressiveness which the commodity system and its spectacle, spanning as they do both these aspects of the old world, have swiftly gnawed to the bone. All we can do now, therefore, is to search in Surrealism, as we might in any culture, for the radioactive radical nucleus that it contains.

The occupations movement of 1968 did precisely that, reinvoking the violence of Surrealism's profoundest impulses. This applies even to the anachronistic and longwinded diatribes of the Surrealist review L'Archibras, which, in June 1968, could still write:

> Let us continue to profane the war memorials and turn them into monuments of ingratitude. (It must be said that only a nation of pigs could have had the idea of honouring the unknown soldier—let us hope that he was a German deserter!—by placing his tomb beneath a grotesque triumphal arch, which, with its four legs spread, seems for all the world to be shitting on that poor devil sent one snowy day to shed his red blood for the blue line of the Vosges.)

It also applies to the incendiary rant, fully worthy of Péret, issued by a "Surrealist Liberation Group":

If you are in despair, if you are suicidal from boredom, it is time to stop acting against yourselves. Time to turn your anger against those who are really to blame for your predicament. Burn down the churches, the barracks, the police stations! Loot the department stores! Blow up the stock exchange! Shoot all judges, bosses, trade-union potentates, cops, and slave-drivers! Wreak vengeance at last on those who take their revenge on you for their own impotence and servility!

But it was no doubt outside Surrealism, and in large measure thanks to those who defined themselves in contradistinction to it, that that irreducible kernel of freedom which Surrealism had so faithfully yet so maladroitly championed was most effectively reaffirmed. Returning for the first time to the movement's roots, and viewing it clearly in the context of today's historical conditions, these opponents of Surrealism readdressed a problem that had been alternately lost and found in the ebb and flow of the Surrealist tide: the problem of the total human being's self-realization under the sign of freedom. Seen from the standpoint of this aspiration, the Surrealists may surely be said to have been what Breton wanted them to be, namely, that minority whom he described, in "Prolegomena to a Third Manifesto of Surrealism Or Not", as "those who *rise* with every new program which promotes the greater emancipation of mankind but which has not yet been put to the test of reality". To these Breton granted the grace of a perpetual ability to start afresh:

> In view of the historical process, where as we well know truth manifests itself only as a knowing chuckle, and is never really grasped, I must at least declare my allegiance to this minority, who are endlessly renewable and who always act as a lever: my greatest ambition would be fulfilled if I could somehow ensure the never-ending transmissibility of their theoretical contribution after I am gone.

TRANSLATOR'S ACKNOWLEDGEMENTS

Many, many thanks to those friends who generously read all or part of the translation and gave me the benefit of their advice (even if I did not always follow it): Jim Brook, Bruce Elwell, Paul Hammond, Cathy Pozzo di Borgo, Florence Sebastiani, and John Simmons. On the design and production fronts, I am most grateful to Marsha Slomowitz, the AK collective, Freddie Baer, and above all to Anne Cordell. Thanks too, once again, to Mia Rublowska for all kinds of vital help.

In handling quoted material I have relied on the existing translations listed below (though I have occasionally made changes). I gratefully acknowledge my debt to the translators and publishers concerned. All other translations of quoted material are my own.

Breton, *Arcanum 17*, translated by Zack Rogow (Los Angeles: Sun and Moon Press, 1994)

Breton, "Introduction to the Discourse on the Paucity of Reality", translated by Richard Sieburth and Jennifer Gordon, *October* 69 (Summer 1994)

Breton, "Legitimate Defence", translated by Richard Howard, in Franklin Rosemont, ed., *What Is Surrealism? Selected Writings* (Chicago: Monad Press, 1978)

Breton, *Mad Love*, translated by Mary Ann Caws (Lincoln and London: University of Nebraska Press, 1987), including Breton's poem "Sunflower", translated by Caws and Jean-Pierre Cauvin

Breton, *Manifestoes of Surrealism*, translated by Richard Seaver and Helen R. Lane (Ann Arbor: University of Michigan Press, 1969)

Breton, *Nadja*, translated by Richard Howard (New York: Grove Press, 1960)

Breton, *Surrealism and Painting*, translated by Simon Watson Taylor (London: Macdonald, 1972)

José Pierre, ed., *Investigating Sex: Surrealist Discussions 1928-1932*, translated by Malcolm Imrie (London: Verso, 1992)